Michael Thomas

Elusive I:
Kutch

A personal photographic journey
ten years after the earthquake

Pipal Press

front cover photograph: Balconies, Ranivas Palace, Darbargarh, Bhuj

ISBN 978-0-9563813-1-6

First published in the UK in 2012 by
Pipal Press
5 New Road
Reading
RG1 5JD

Printed and bound by Calverts, The Oval, London, E2 9DT

Foreword

One of the most formative of my travel experiences came in October 1988, when I and my BBC crew had just embarked on a re-creation of Phileas Fogg's journey, *Around the world in eighty days*. The problem was that Phileas was fictional and we were doing it for real. After a run of very bad luck, our series was saved from possibly terminal disaster by the Al Shama, a dhow travelling from Dubai to Bombay. The captain and crew nearly all came from the coastal town of Mandvi in Kutch. They were friendly, hospitable and generous, and I promised that one day I would see them again. But as happens, time races on and the next time I heard of Kutch it was for all the wrong reasons. In January 2001 a powerful earthquake shook the area, causing enormous damage and thousands of deaths.

It was not until the autumn of 2008, almost twenty years to the day since our voyage on the Al Shama, that I finally kept my promise and visited Kutch for the first time. The capital Bhuj still bore the scars of the earthquake; the graceful Jubilee Hospital was in ruins, and the magnificent Durbar Hall was a dusty wreck, but the spirit of the people was resolutely un-broken. In Mandvi I met up with Captain Suleyman and others who'd helped us across the Indian Ocean two decades earlier. We shared much laughter, and some sadness, as we watched the original film together, and then I was taken on tour of shipyards where dhows are still being built. Kutch always held a place in my imagination and having now seen the real thing and met some of the people who live there, I know it is a very special place. Its location in the extreme north-west corner of India, with mysterious expanses of salt flats like the Rann of Kutch, melting into the Pakistan border, gives it a singular appeal. As does its sturdy maritime tradition, with old methods still producing good ships.

Having admired Michael Thomas's book on the indigenous tribes of Orissa, a similarly fascinating but less visited part of India, I was delighted to hear that he was turning his humane and curious eye on Kutch. His strong, beautifully composed black and white photographs and his concise, well-informed text give a vivid and easily digested insight into this remarkable corner of India. The richness of its history, the beauty of its buildings, and the indomitable spirit of its people are all captured in these pages. Michael Thomas's unpatronising and unpretentious style suits the material perfectly. This is Kutch how I would like to remember it, and how I would like others to see it for the first time. But not, I hope, the last.

Michael Palin
Actor, author and traveller
London

NAGAR PARKAR FAULT

SINDH

ALLAH BUND FAULT

Pakistan border

Pakistan border

GREAT RANN

GREAT RANN

Khadir Island

Black Hills

⊙ Dholavira

⊙ Lakhpat

Kori creek

⊙ Koteshwar

BANNI GRASSLANDS

⊙ Panandhro

⊙ Hodka

KUTCH

Patan ⊙

⊙ Mata-no-Madh

KUTCH MAINLAND FAULT

⊙ Rapar

Tropic of Cancer

LITTLE RANN WILD ASS SANCTUARY

⊙ Tera

⊙ Daneti

↘⊙ Bhuj

Jakhau ⊙

causeway

ARABIAN SEA

⊙ Kandla

⊙ Mandvi

⊙ Mundra

Gulf of Kutch

KATHIAWAR UPLIFT

⊙ Jamnagar

GUJARAT

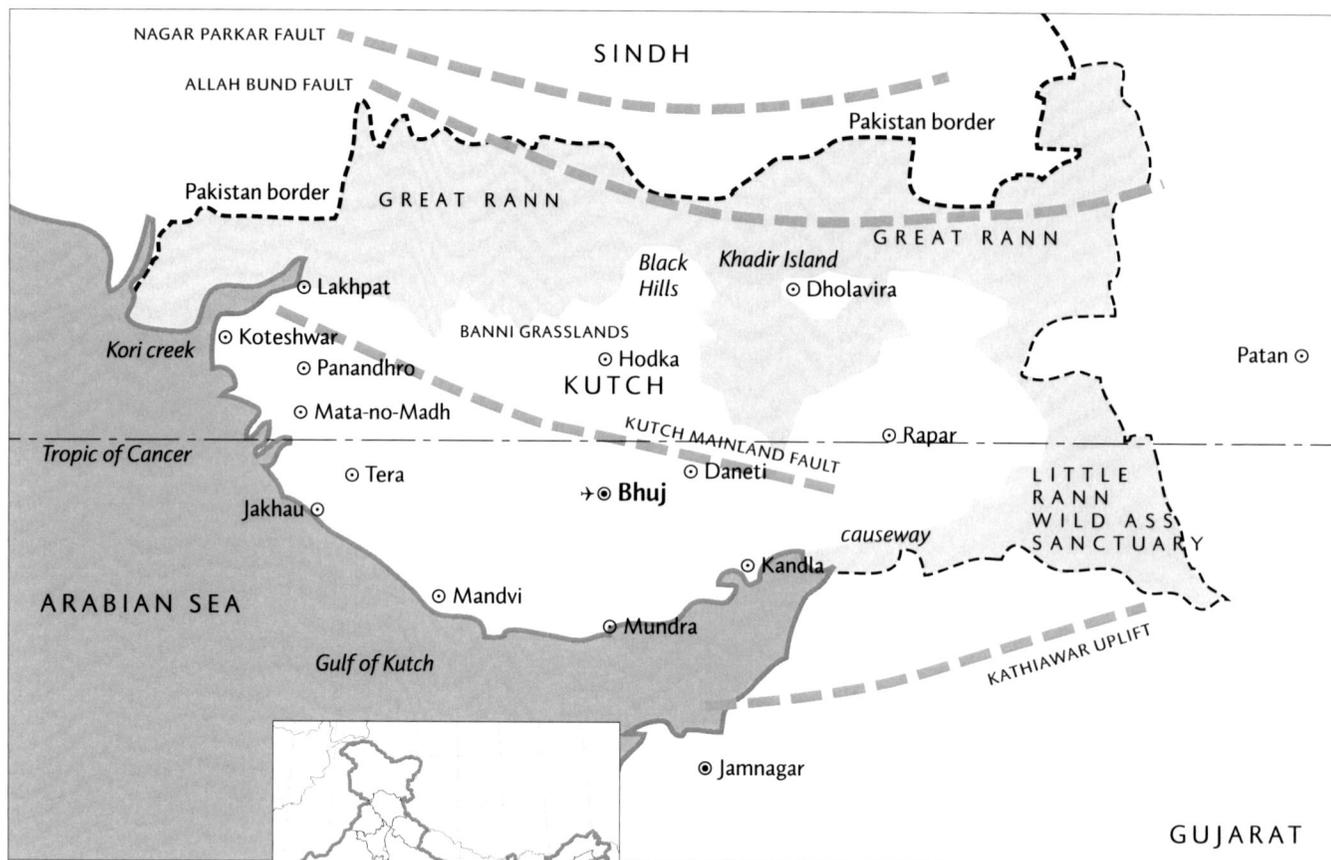

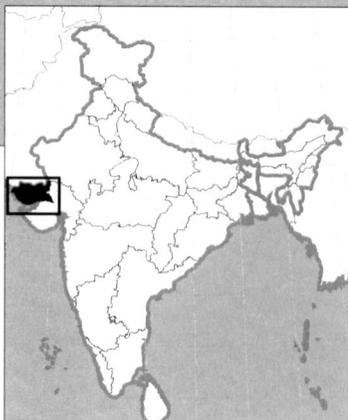

Maps showing the location of Kutch.

Introduction

Why Kutch and where is it? How did I come to visit this area in 1995? I had travelled to India a few times and one travel book caught my interest. It described a place called Bhuj as a walled city in near desert, where the city gates were locked each night. That was just a few decades earlier. I felt an urge to go to this intriguing place, free of the tourist trail, so planned a trip. A few days before leaving England I visited my father and asked to see a silver sugar shaker which was one of the few things that my mother's family had brought back from Calcutta. As a child I had played many times with this wonderful decorative piece full of flora and fauna. It was still stiff with sugar. I turned it over and stamped on the bottom was the maker's mark and 'BHUJ': the power of the subconscious memory had struck, and I was rewarded.

My first visit was a rapid tour of Gujarat and included such wonders as the 900 Jain temples at Palitana and the fort at Diu. Kutch however is very different. Some 1200 years ago it was an island and had a strong association with Sindh (now in Pakistan). Its history is one of independence and that spirit continues. In 1947 it was designated as a state and now it is a district of Gujarat, just one hour's flight north of Mumbai. In the last fifteen years, I have travelled to Kutch several times and learnt that it has a long and complex history. Each visit brings new encounters, vivid experiences, and the people are delightful. It is not like the lush green palms of Kerala or the robust colourful Rajasthan; it is more subtle.

There are very few books that give a broad overview of this multifaceted district and they are sparsely illustrated, with one exception, so I wish to remedy that. I rely on my black and white photographs to tell most of the story but there are two factors that are uniquely important to the way Kutch has evolved. These are its remarkable geology and unusual history. I have, therefore, split the book into two parts: the first explains the geological evolution and provides a brief history. As far as I know this is the first such attempt to summarise the history from 5000 years ago to the present day, and that explains the essence of the development of Kutch and its people.

The second part is selective personal wandering. I am the observer, armed with curiosity and a camera, and want to show some of those things that I have come across by chance or interest me. One objective is to present a photo documentary of aspects of Kutch as I see it now, ten years after the earthquake, and to note areas where there are changes, which will have a marked effect on the people, their various cultures, and the landscape. I have tried to summarise the current situation and suggest what the future holds. I have been objective about this so that others can draw their own conclusions. I have relied on many, often conflicting, written and verbal sources for my information which cannot be credited item by item so what I have written is offered in good faith.

Generally, I have avoided the well-known monuments and instead tried to catch something of the spirit of Kutch. Some specific subjects such as textiles and crafts are well documented elsewhere so I have made very little of these here. Instead I have added a suggested reading list, which I hope will point readers towards their own areas of special interest.

Changes are happening now, and very quickly. This, then, is a current personal selective look into this unusual area which I hope will be more than just a record but a stimulus to explore this unique place.

I owe thanks to Judy Frater for sparing time to check that my facts are broadly correct and to Sue Walker for her help with the book design.

I dedicate this book to my daughters, Jo and Emma.

Geological evolution

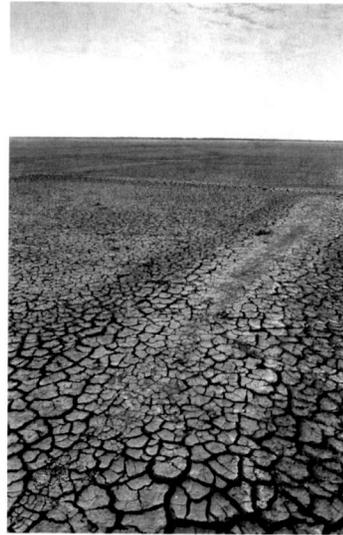

The Little Rann, old salt pans and the edge of Kutch on the horizon.

Kutch lies on the far northwest coast of India projecting into the Arabian Sea and close to the Pakistan border. It is the largest district in the state of Gujarat, separated only by the Gulf of Kutch, and the second largest district in India, yet it feels isolated. This has much to do with its most unusual and complex geological origins.

Around 160m years ago the supercontinent of Gondwana, which included the African plate, began to break up. At that time India was conjoined with Madagascar but about 90m years ago, due to the continental drift, India split away. It fused with the Australian plate around 55m years ago and pushed against the Eurasian plate, which in turn formed the Himalayas. This left Kutch as an island in the Arabian Sea and on the edge of the Indo-Australian plate. Later, under great compressive forces, this created a volatile zone prone to the many earthquakes which have had such an effect on its people and places.

The river Indus ran into the Arabian Sea via seven routes and the southernmost ran above Kutch until between 1000 and 2000 years ago, when tectonic instability caused a major upheaval which virtually shut the northern waterway to the sea and left a vast inland freshwater lake. Then it was still easily navigable and accessible to the fertile plains of Sindh. Over time, this became the unique and amazing saline wastelands called the Great and Little Ranns separated by the highlands of Kutch and the low-lying sedimentary Banni Grasslands, which were to become attractive to migrant cattle herders and camel breeders.

The area of Kutch is about 50,000 sq km and there is a great variety of geological formations ranging from sedimentary rocks of different ages and densities to three ridges of Jurassic rock running approximately east to west while the coastal areas have more recent thick alluvial and marine sediments. There is evidence from the very early period of ammonites and other fossils. Large areas are covered by basaltic lava flows from the Deccan Trap.

Over the past 200 years four main fault lines were recorded as running roughly from east to west. One, the Kachchh Mainland Fault, produced the devastating effects of the 1819 and 2001 earthquakes. T. Oldham's catalogue (1869) records the former as *'most severe and destructive earthquake on record in India … Bhooj…reduced to ruins, 2000 people perished … shock lasted from 2 to 3 minutes with heavy appalling noise…'* It also created a 100 km ridge called the Allah Bund fault in Sindh, which diverted the Sindhu River, leaving Kori creek as a minimal link with the sea and now in the monsoon strong westerly winds flood the Great Rann with salt water. In 2001 there was another massive earthquake centred near Bhuj, recorded as far away as Madras and Kathmandu. Nearly 20,000 people died, 40 per cent of homes were destroyed; many historic buildings and the infrastructure were severely damaged. One might imagine Kutch as a ruined, desolate place, but that is not the case at all.

A brief history

Although it was an island, Kutch was linked strongly with Sindh in the southern part of the Harappan or Indus Valley Civilisation (5500 to 3500 years ago) which stretched as far as the Iranian border, and included Punjab. At that time this mainly agrarian and well-organised civilisation was larger than Mesopotamia and Ancient Egypt put together. Dholavira, a port on Khadir Island, in Kutch was one of the five most important cities from 3000–1500 BC and was only discovered in 1967. The maritime and trading strength of Kutch, from Zanzibar to Oman, was long established and this was to remain. By 500 BC Darius 1 (the Great) of Persia annexed Kutch for this reason.

It seems fair to say that Kutch was not unified until the 1500s. It comprised various fiefdoms most of which belonged to clans that migrated from the north and Persia. This was a period of empires by battle and alliance. Alexander the Great is said to have visited Kutch in 325 BC yet after taking control of part of north India, he marched mutinous troops directly along the Indus, across the Gulf to Susa before his death in Babylon in 323 BC aged only 32. His effect on Kutch will have been minimal.

The strongest connection in this period was with Sindh, although the Kutchi sea ports acted as an important trading 'bridge' between north and south. This was the time of the powerful Hindu Mauryan Empire in the northeast, which swept across to the west. At its peak it controlled most of India under its leader Ashoka the Great; that is until Ashoka became a Buddhist thus renouncing war and after his death the Empire fragmented. This had been a great period of political and military unity, better productivity, improved trade and fairer taxes. Next came the benign Greco-Bactrian rulers from the northwest. Lasting almost two centuries any conflict was between chieftains.

From 100 BC to AD 300 the Western Satraps from Central Asia ruled until the dawn of the Classical Age when Samundragupta overthrew these Saka rulers. The Gupta Empire was a period of remarkable scientific and artistic development and extended across north India until around AD 550. Kutch became increasingly under the control of the organised and powerful Alor, a province of Sindh. Koteswar in Kutch was an important port at that time and traded highly prized African elephant tusks, an example of Kutch's maritime value. Buddhism was in decline whilst Jainism was on the increase which it has since maintained. Kathi tribesmen from Sindh moved into Kutch on their way to seize Kathiawad (now Saurashtra) in Gujarat and Charans and Ahirs came from the mainland to the east effectively dividing the territory between them. There had been fear of an Arab invasion as India was rich in minerals and the only known source of diamonds. By AD 712 they had conquered Sindh but did not annex Kutch.

After several wars Samma Rajputs from north of Kutch defeated the invaders who were largely checked in Sindh. A group of Samma Rajputs led by Lakho Ghuraro migrated to Kutch around AD 800 and established a small kingdom in Eastern Kutch under liege to the Chawras with whom they had a blood relationship. In spite of violent internal conflict between the Hindu and Muslim branches of the Sammas they increased occupation and held rule of the whole of Kutch until AD 985. A notable king was Lakho Fulani, a strong patron of architects, who greatly enlarged and fortified Kera his capital south of Bhuj. He was succeeded by his nephew Punvro who promptly built a fort near Nakhatrana. He was renowned for his cruelty and remembered by legend whereby seventy-three supernatural horsemen of the god Jakh caused his death; several versions of the story survive today. As there was no heir, an opportunist soldier, Ahivanraj Chavda, with the help of his Chavda kinsmen established himself as ruler and the line continued for 130 years.

The Jadejas

In AD 1147 Jam Lakho Jadeja, having no future in Sindh, was soon to control central Kutch with little resistance.

He was a descendant of the earlier Lakhos but adopted at birth by a Samma chief called Jada so adopted both titles. He ruled until his death in AD 1175 and power passed to his son Rayadhan, a mighty warrior who extended the territory to most of Kutch. On his death in AD 1215 the land was divided between his four sons who were bitter about the share. Otha, the second son, became the dominant leader leaving the others and their descendants to feud in clan warfare. This continued for three centuries and in relative isolation. Part of this was due to Kori Creek which started drying up in AD 1226 and communications with Sindh were cut off, except by sea, until new routes were established; close political relations continued. By AD 1365 this vast area was dry and waterless and the Rann or wasteland was born. Thus Kutch was largely left alone by the mainland and the five Islamic kingdoms of the Delhi Sultanate which ruled north India from 1206 to 1526. That is apart from paying tribute.

These were rough medieval times and Kutch was not short of conflict, connivance, deceit and plain murder. The Kutchi seamen had a reputation for piracy but there was also a strong religious side. The goddess Ashapura was the highly revered family deity of the Jadejas. Hamir, a descendant of Otha, in thanks for a favour, enhanced her temple and the guardians at Mata-no-Modh in the north. This is one of the most sacred shrines in Kutch and a place of pilgrimage today.

The Maharaos

There is one particular sequence that was to set the pattern for nearly 450 years. In AD 1506 Lakho, a descendant of Rayadhan and his son Gajan, whilst passing through territory controlled by Hamir, was murdered. Rawal, Lakho's son, suspected wrongly that Hamir was responsible and had him assassinated. This changed the course of Kutch's history. Rawal went on to destroy the royal family and reigned over the whole of Kutch. But two sons of Hamir fled to Ahmedabad and one of them, Khengar, who was only 11 years old, enlisted in the army of Muhammad Begra. All this became the stuff of legend

as just three years later Khengar saved the Sultan from being mauled by a lion when on a hunting trip. In return he gave Khengar the title of Rao and 1000 soldiers to help him to retake Kutch. This he did as Rawal lost support and moved south to take power in Kathiawad. Khengar became the 1st Rao of Kutch in 1549 AD, the first to unite Kutch under Jadeja rule, and later established Bhuj as his capital. It was here that he created the striking reservoir which he called Hamirsar Lake after his father. One surprising aspect of Kutch's history is the fact that Muslims and Hindus were often in collaboration and even in the same clan such as the Sammas.

It is well known that Babur, who came from what is now Uzbekistan, made a series of raids from the North West and by 1526 had defeated the last of the Delhi Sultans and thus began the Mughal Empire. As before this was not to affect Kutch which by now had a strong army, a strong leader, and formidable reputation. By 1573 Akbar conquered Gujarat but merely required Khengar I to acknowledge the imperial authority without even paying tribute. At this time sea power was becoming important and the Portuguese had established a settlement at Diu. However, they were respectful of the Kutchi seamen and both traded peacefully; in fact Kutch power in the Arabian Sea grew greatly.

It seems that successive emperors and raos of Kutch had mutual respect for each other and one interesting example occured in 1617 when Jahangir gave Rao Bharmal the right to strike his own coinage, the kori, and a rare privilege for a subservient kingdom that lasted until 1948. Another deal was also struck. Jahangir gave full and permanent remission of all tribute from Kutch in return for granting pilgrims free passage to Mecca in Kutchi ships. Having little contact now with Sindh, Kutch was able to be independent of Gujarat and owe allegiance directly to the Mughal Empire without payment.

There is an important aspect regarding the division of land, administration and external affairs that deserves explanation as it has much to do with events in Kutch's later history and that is the *bhayyad*. The word has been

translated as 'brotherhood' and in this case relates to younger brothers, sons and cousins of the Maharao. Each was a feudal chief of his own land and owed allegiance only to the Maharao who was not able to levy any taxes to run the administration. The only obligation was for the *bhayyad* to support the Maharao with forces in case of external threat. Thus the Maharao was reliant solely on his own resources from his own land, about half of Kutch, to rule the state.

Succession in the Jadeja line continued generally on the basis of primogeniture. There were exceptions which led to temporary fragmentation of the state but in 1719 Desal I became the ruler who proved to be successful and popular. His even-handed approach to differing religions for example led in due course to an almost united and prosperous Kutchi nation. This was just as well as the Mughal Empire, which had been a good protector, began to break up and Gujarat with increased independence started to look towards Kutch. This caused Desal I to strengthen the fortifications around Bhuj and nearby Bhujia hill. In 1730 the Governor of Gujarat, Sarbuland Khan, took a huge army and crossed into Kutch but after a fierce battle and a surprising rout, Khan and his Mughal supporters fled with enormous losses. As a result Desal I's reputation was greatly enhanced and his Diwan (Chief Minister), Devkaran Seth set about successfully extending cultivation and improving the defences of major towns. Kutch became prosperous.

By deceit Maharao Lakho took control from his father Desal I and the development of Kutch changed. By coincidence a seafarer, Ram Singh Malam, was shipwrecked and taken by his rescuers to the Netherlands. Here he learnt many skills including engineering, foundry work, tile making, glassblowing, gold and silver work and more. He returned to Kutch and after a while his skills were recognised by Mandvi traders. Lakho, who had a strong curiosity about the wider world, and who welcomed new ideas, took Ram Singh under his patronage and together they set up many enterprises to develop these skills and techniques, at vast expense. Ram Singh, for exam-

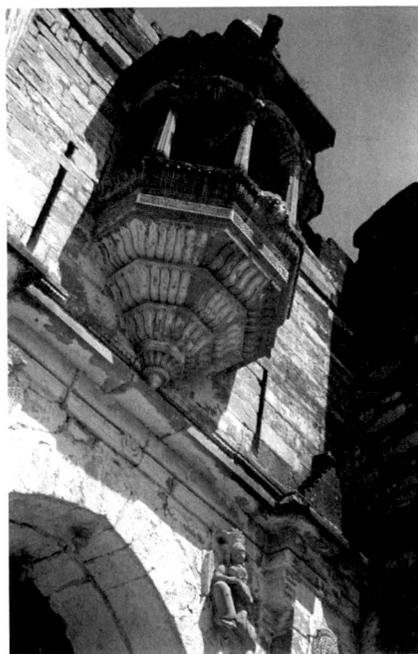

Tera fort now deserted. The main hall has a 23m series of important fading frescoes that tell the story of the Ramayana.

ple, designed a new cannon and as Lakho thought that Thakur Sumra of Tera Fort needed to be brought into line he sent forces with the cannon. Peace was quickly settled. Ram Singh's masterpiece is the Aina Mahal in Bhuj which is now a fascinating museum where much of this work can still be seen in spite of later earthquake damage.

At Lakho's death in 1761, notwithstanding his lavish expenditure on his many projects and lifestyle, his able Diwan, Jivan Seth, had ensured that trade flourished, land revenue increased, and taxation was low. His son Maharao God II, then aged 26, made few changes but Kutch's power was seen as a threat by the King of Sindh who decided to teach the Maharao a lesson. There followed two wars with great loss of life and damage to Kutch. The King of Sindh settled by taking a cousin of the Maharao as his wife. However, Maharao God II, despite his reputa-

tion for being cruel and mean, was clever and regained stability, increased cultivation, and commerce flourished. He took a personal interest in shipbuilding at Mandvi which became famous all over India and one ship even sailed with an all-Kutchi crew to England and back. This expansion was against the trend when much of India was changing as the Mughul Empire was waning and commerce diminishing.

On his death his eleven-year-old son, Rayadhan II ruled but shortly after anarchy, chaos and confusion reigned for the first time in Kutch. The Maharao had long fits of madness and his young half-brother Prithiraj was chosen to fill his place against all legal precedent and a council of regency governed. In sane moments Rayadhan II was shrewd and he appointed Fateh Mohammed, a soldier-statesman who as regent took over the State in 1786 and restored order. He did more. He enhanced the army, subjugated Mandvi and built a huge fort at Lakhpat as a defence against the now fragmented and volatile Sindh. Everything was set for a period of prosperity but the now adult Prithiraj was jealous of Fateh Mohammed's power; he took over Bhuj only to die shortly after in 1801 which allowed the mad Rayadhan II to reappear and Kutch became divided under rival Diwans.

British influence

The English East India Company had just become established in Gujarat, and was entreated to mediate and take over this remote state. However the Company's trade was being affected by piracy organised from Kutchi ports and interference on land. The British were also busy with Napoleon. It was a fixed policy to exclude the French and Americans from every part of India, so the Company had formed an agreement with Sindh to prevent foreigners settling and now saw Kutch as a weak point; it also needed to stop Kutchi depredations. Two agreements were made in 1809 and these were largely ignored by the Diwans, but now the Company was much more aware of Kutch and its importance. Lt. MacMurdo, who was remarkable in that he had lived for a year in Kutch in the

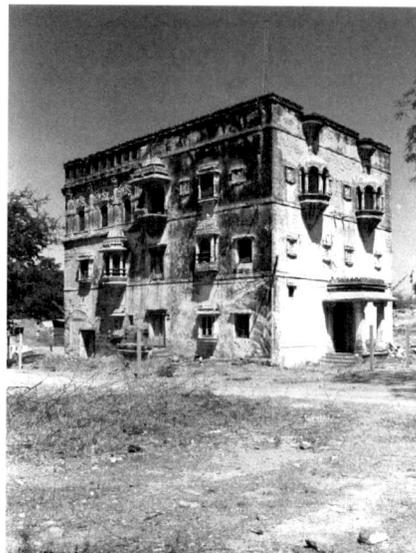

Fateh Mohammed's Khordo in Bhuj 2010. This was due to be converted into a museum and culture centre before the earthquake of 2001.

guise of a Sadhu, known as Ramanadi, and spoke the language fluently, was sent to Mandvi to issue warnings. In spite of promises and an ultimatum, power struggles continued notably a civil war between Bhuj and Mandvi, so nothing changed. Then Fateh Mohammed died of bubonic plague as did nearly half the population of Kutch.

For the first and last time in the history of Kutch and without an acknowledged heir, Hindus and Muslims found themselves as rivals for power. The upshot was that Mansingh, a natural son, became ruler in 1814 with the title of Bharmal II. There followed a short but turbulent time in which feuds, raids, pillaging and piracy continued to the point of civil war. After more quarrels the Company under MacMurdo, now Captain, attacked then moved towards Bhuj where the comprehensive treaty of 1816 was signed and this brought Kutch into a select group of states that had a formal alliance with the Company. MacMurdo was appointed Resident at Bhuj and Collector of Anjar where he built a bungalow with Kutchi

style wall paintings. It still exists. What should have been a peaceful time was not. The British had completely misunderstood the relationship between the Maharao and the *bhayyad* who had by now become the main administrative contact with the Company; in consequence confusion and dissent reigned between the British, the feudal Jadeja chieftains, and the dissolute Maharao. By March 1819 an ailing Maharao Bharmal was deposed and succeeded by his infant son Desal II, bizarrely elected by the *bhayyad*. At a stroke the Company had reversed two hundred years of Kutch's political evolution towards a central authority.

On 16 June, tremors which led to the famous earthquake began and the shocks went on for six weeks with disastrous effects on the landscape, buildings and huge loss of life. Moreover Kutch was susceptible to raiders, looters, even invasion from Sindh and Hyderabad. It seems that the British residency under MacMurdo and his successors were able to find resources that held the state together and chaos was replaced by order and efficiency. This was a point of change in policymaking. Now it was the turn of the civilian leaders rather than the great soldier Diwans to direct and lead. But the Jadeja chiefs much preferred to remain in their fiefdoms, relying on British protection and making no effort to provide aid to their ruler or to protect his towns from plunder. In 1830 the governor of Bombay visited Kutch and rebuked the chiefs for neglecting to give allegiance to the prince; this probably made little difference. In fact the chiefs asked that Desal II, now fourteen years old, take up administrative duties and that the tribute to the British be reduced. The first was agreed but the second was not because half the useful land yielded no dues and the cost to the British was heavy anyway. When the British Resident took over the Regency the administration moved from Anjar to Bhuj and a further treaty wiped out the Durbar's debt and payments capped. Things settled down; foreign trade by sea was important and the economy boosted by increased animal husbandry. Desal II was bright, well-educated and understood public affairs so by 1834 the Regency was

wound up and the Maharao put in charge of government albeit with constraints. The young Prince saw clearly that this was an opportunity to restore the power of the Durbar.

The *bhayyad*, as before, took no interest and the prince worked well with the British and their ideas. One was the matter of slavery which had a long trading history in Mandvi and after just two years Desal II published an order involving the impounding of vessels which effectively crushed slavery in Kutch. Similarly the Maharao was in due course able to abolish infanticide. Through good administration and relations with the *bhayyad* and the British, he became one of the most able rulers of Kutch yet in spite of his entreaties he was unable restore the power that the Maharaos had enjoyed before the great British error in 1819. Kutch could have been much more prosperous had the British understood the system. This was a long period of peace and even in 1857, the year of the mutiny, Kutch was untouched.

Desal II died in 1860 and was succeeded by his son Pragmal, a modern man and well suited to continue his father's work. The Company was gone and Queen Victoria guaranteed the treaties with princes. The British had seized Sindh so Kutch lost its strategic importance and started to return to its traditional isolation with limited natural resources. The emphasis shifted towards increasing far-flung commercial connections through successful maritime trade. A strong administration was necessary and the British realised that Kutch was constrained by their own treaty of 1819. Pragmal II took his case to London and gained some ground but all this took a great deal of time and effort; in effect it prevented the rulers of Kutch from building up an efficient administration which would have secured its future in the 19th century. In spite of Pragmal's great abilities Kutch was held back and much of the state became fragmented. His successes were trade, commerce and many useful public works, notably a system of state education, which by the time he died included 71 schools and the creation of three libraries. With slender resources it is surprising that he was able

to complete many civil works, harbour improvements at Mandvi, tanks, road works, a causeway across Hamirsar Lake, a jail, a hospital and even the Prag Mahal Palace (started 1869) in Bhuj for himself. Pragmal died in 1876 aged only 37 and in recognition of his accomplishments Queen Victoria appointed him KGC of the Star of India.

His ten-year-old son, Khengar III, followed, under the guidance of the Council of Regency. The Council built upon Pragmal II's administrative model and set up seven subdivisions with its own revenue and judicial officer; these still exist today. The Maharao learnt quickly and proved to be a very able successor to his two predecessors. He visited London with his brother in 1887 and made his mark with Queen Victoria on her Golden Jubilee. She apologised that she could not go to India as at her age the sea voyage would be too much. Back in Kutch he continued the work of Pragmal II and developed more land for cultivation, built more schools, made harbours and many infrastructure improvements. If he had enjoyed resources equivalent to other princely states, Kutch would have been a model. He was ahead of his time.

Kutch is within the 'famine belt' and suffered from the vagaries of a failing monsoon, drought and famine and the real chance of increasing revenue was external trade. Due to the extraordinary geological events the Ranns are perhaps the largest natural supplies of salt in the world, which had produced a great source of income for the Mughals. The British decided to take salt under their control too and in 1885 the Durbar was required to sign an agreement pledging itself from exporting salt to any part of India by land or sea. There were restrictions regarding export to other countries thus effectively killing off marketing salt commercially.

Morvi, on the other side of the Gulf of Kutch, had become a state and this threw up a number of conflicts not least the maritime rights of the Gulf itself. The matters were settled to the detriment of Kutch in the 'Kennedy Award' and the Maharao continued to fight this at the highest levels but failed. Morvi however was able to flourish and became wealthy as a result.

Relations between the British and the Maharao remained cordial, and the latter was rewarded for his services in the First World War but the post-war years proved difficult for most of India as the country moved towards independence. Kutch however carried on in its traditional conservative ways in spite of its support for Ghandi and the Indian National Congress. It is a measure of the Maharao's standing that after fifty years in power he was chosen in 1921 to represent the Indian princes at the Imperial Conference in London. He received the freedom of the cities of London and Bath and became greatly respected for his breadth of interests such as ornithology, zoology, and extensive travel in Europe. As a senior prince he became one of the best-known Indian princes in Great Britain. He died in 1942 and was followed briefly by his son Vijayaraji, then in his fifties, until 1948 when Maharao Madansinhji became the last descendant of Rao Khengar I to rule Kutch. It was his duty to wind things up before independence and he did well. The *bhayyad* and Durbar debts were wiped out and, although dispossessed of land but keeping costly palaces, he secured the privilege of finance to travel and study abroad and to retain his maritime rights. On 1 June that year the government of India took control of Kutch.

In 1950 Kutch state was created within the union of India and in 1956 it was merged as a district with Bombay state. In 1960, largely for linguistic reasons, it became part of the state of Gujarat.

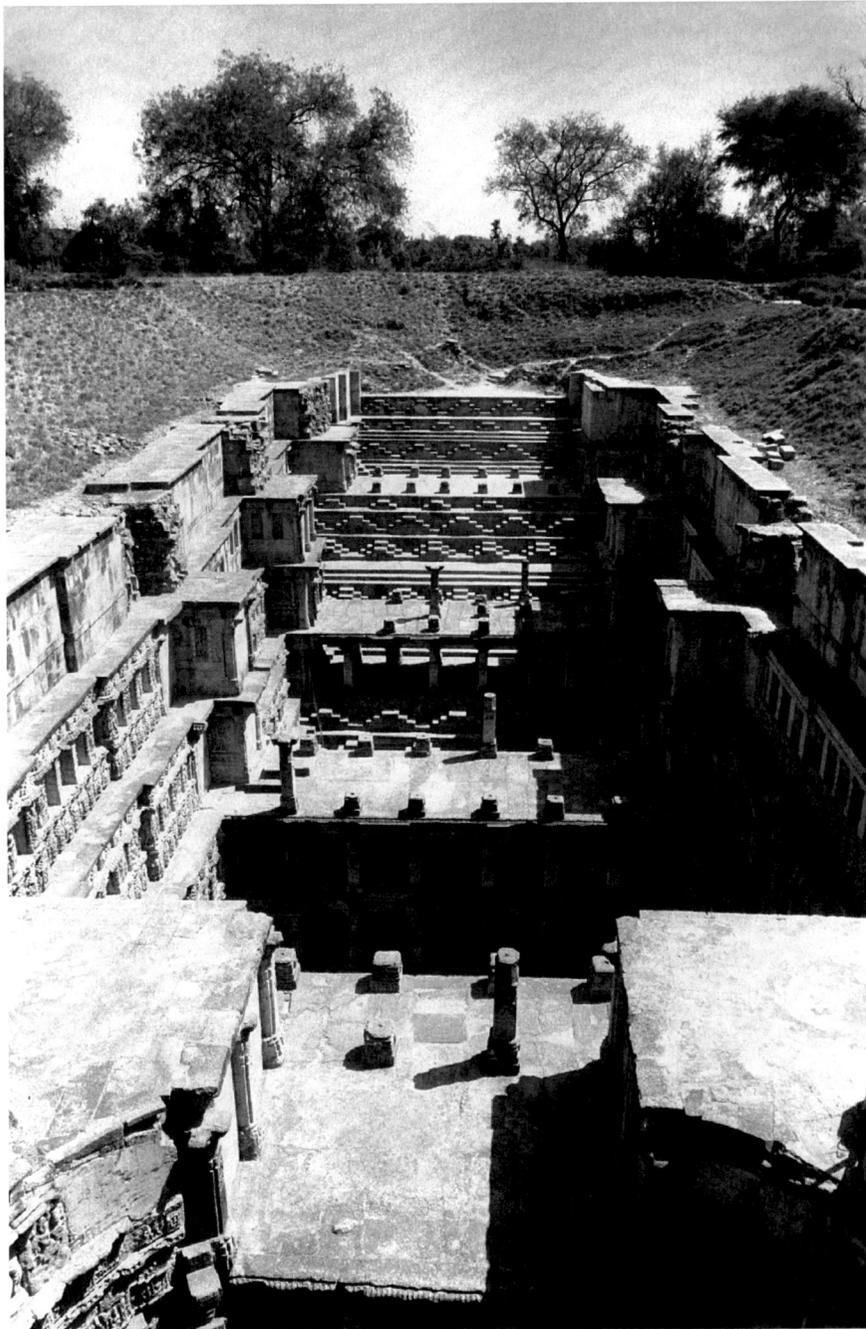

A wander round Kutch

The routes to Kutch are limited. The quickest is by air to Bhuj but I have chosen a more leisurely route from Ahmedabad, capital of Gujarat, and taken a road northwards which passes close to Modhera Sun Temple on the Tropic of Cancer, then to Patan and the wonderful Rani-ki-Vav which is probably the finest step well in India. A few decades ago it was silted up, exposed to reveal superb carvings and then badly damaged by the 2001 earthquake. The Archaeological Survey of India has since restored it. A few miles further there are several remote places to stay and see the wildlife in the Little Rann before crossing into Kutch.

Patan, Gujarat, Rani-ki-Vav (Queen's step well), 11th century AD.

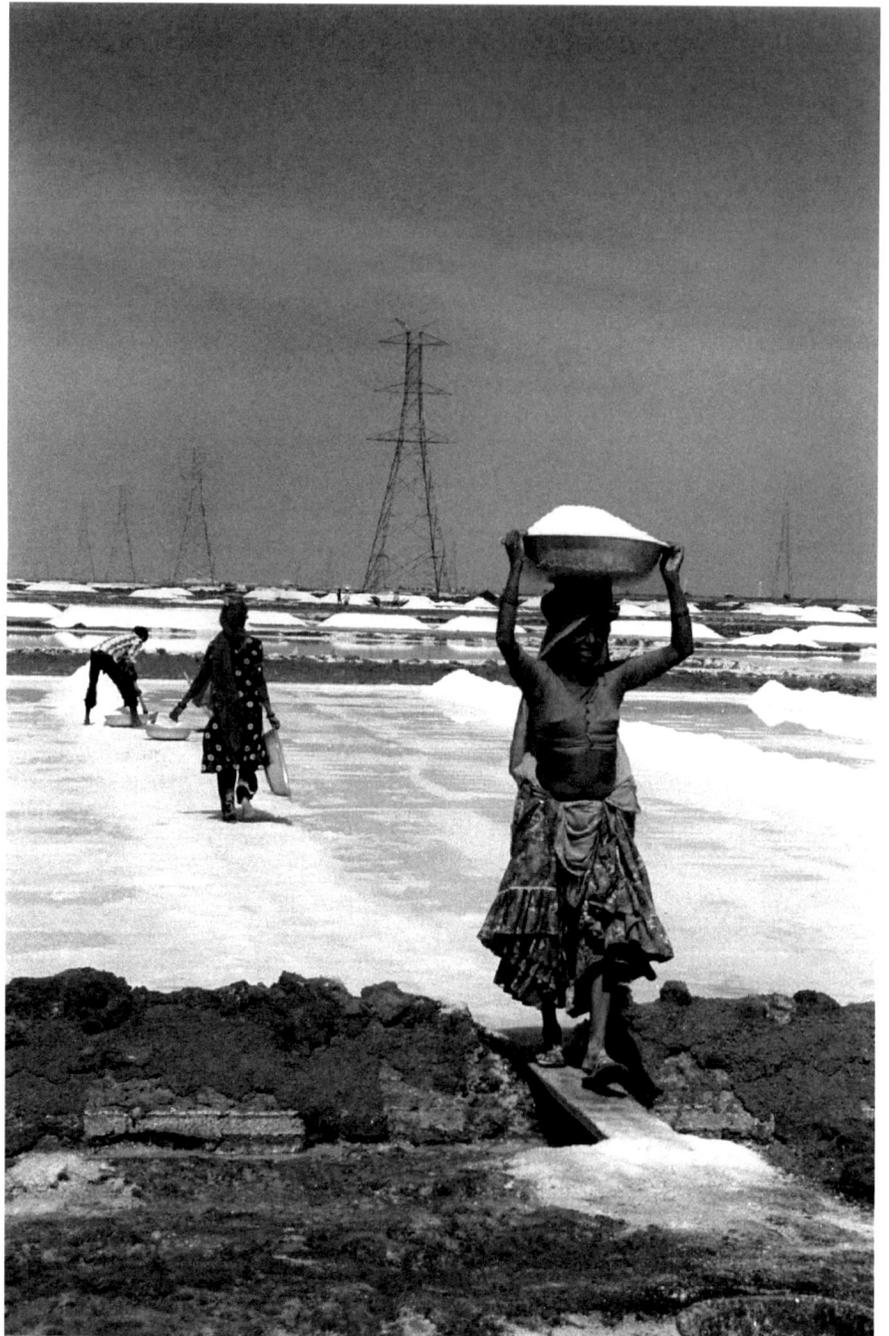

Entering Kutch.

The main road into Kutch is on a causeway, flanked by vast seasonal salt marshes. This is big business which supplies about 20 per cent of India's needs. The salt workers or Agariyas, who work from October to April, earn very little and live in conditions that lack basic amenities.

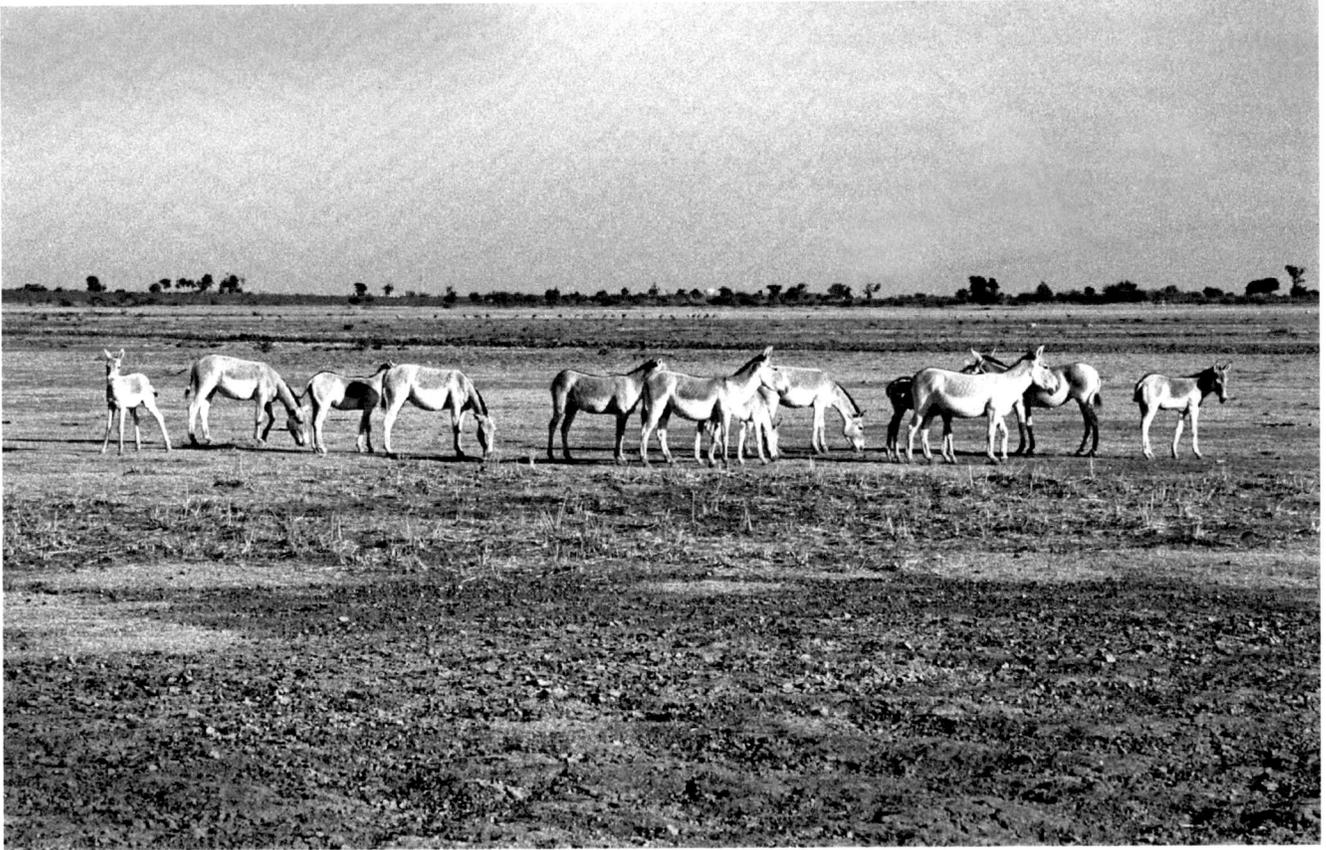

Indian Wild Ass (*Equus hemionus khur*) in the Little Rann.

The Little and Great Ranns provide the largest wildlife Sanctuary in India which is the last remaining refuge for this elegant endangered animal which feeds on grass, leaves and saline vegetation. In the marshy areas and shallow lakes there are over 200 species of birdlife – pure magic at sunset.

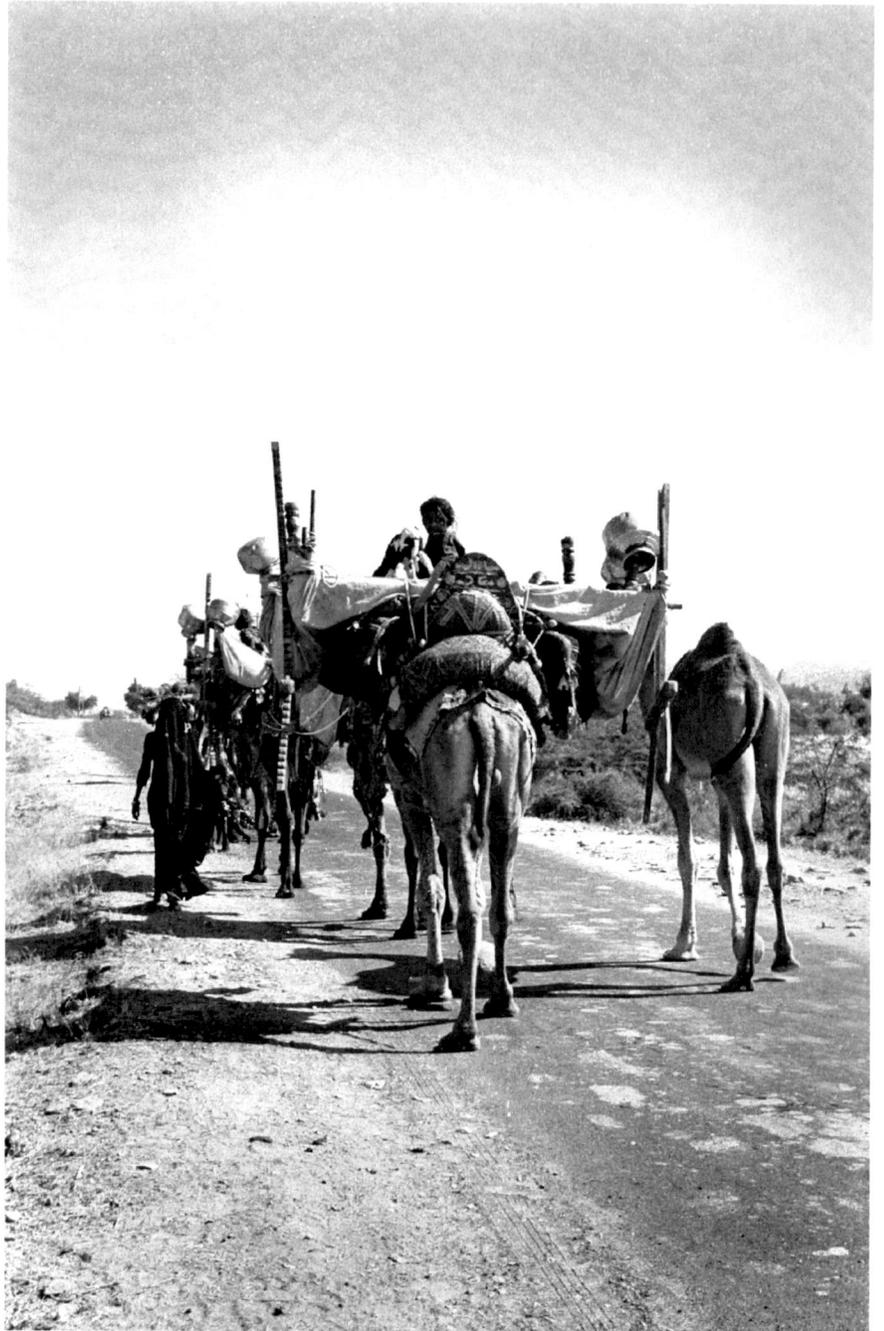

Towards Bhuj.

Semi-nomadic Rabari families on the move with pots and beds. This is a diminishing sight, always amazing and exciting.

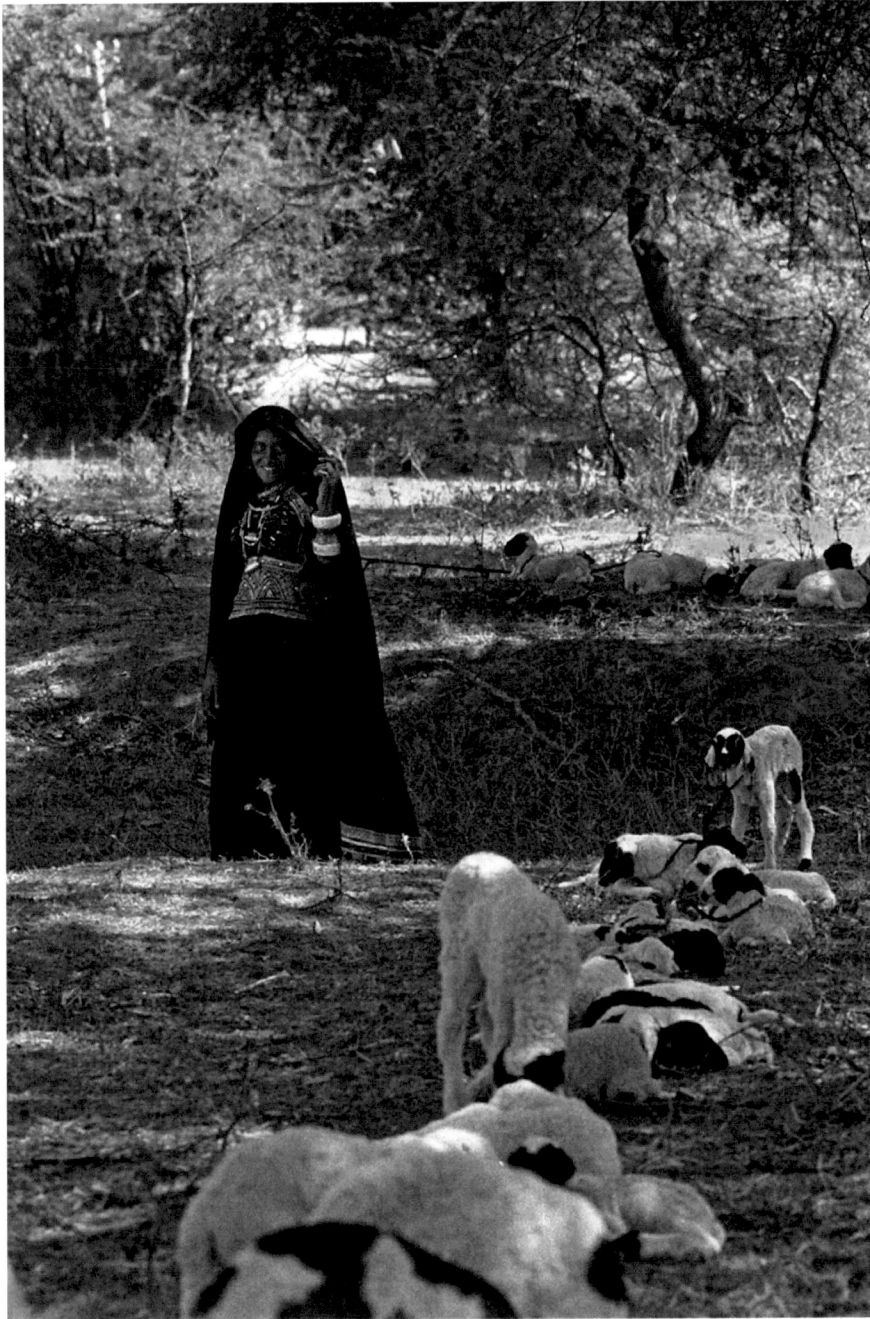

Near Bhuj.

A Rabari shepherdess guarding a string of tethered lambs.

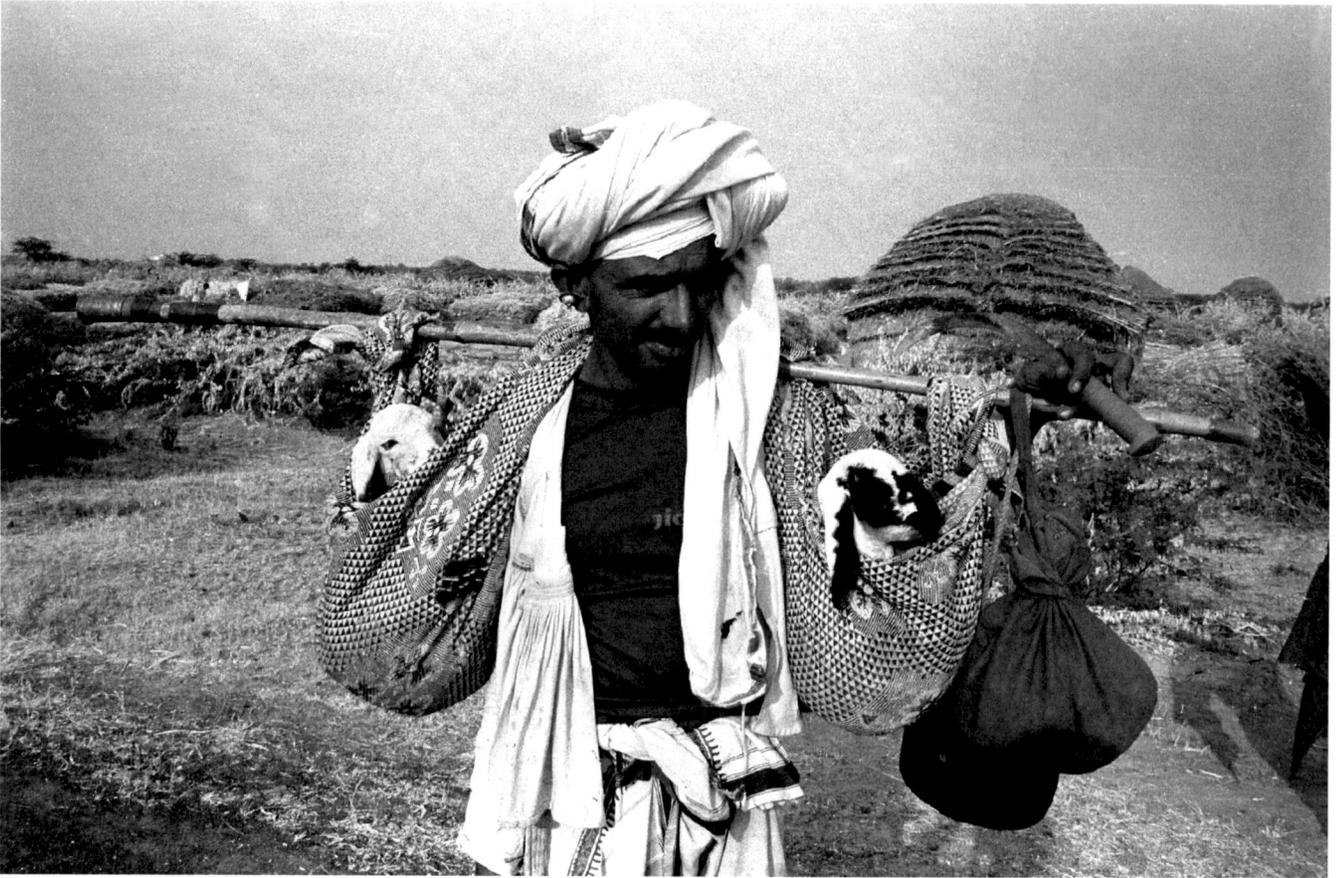

Near Rapar.

A Rabari boy proudly shows off two-day-old
goats and lambs.

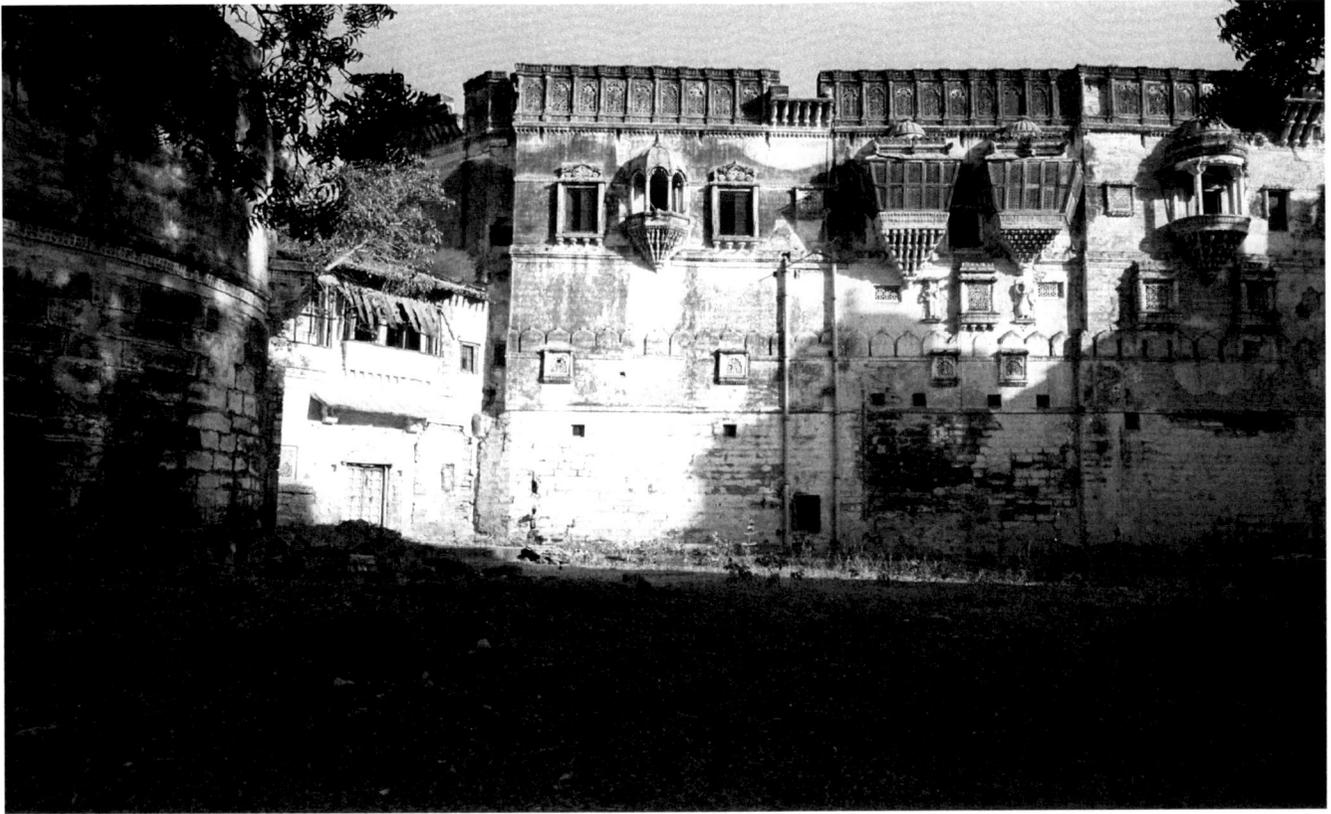

Bhuj, the Darbargarh courtyard.

Bhuj

In 1548 Rao Khengarji I chose Bhuj as the state capital and it remained so until independence. The city was fortified in 1723 by Rao Godji who built a 35-foot-high perimeter wall with five splendid gates. The earthquake of 1819 caused great damage but the wall was partly rebuilt and earlier buildings survived. The city grew but in 2001 another earthquake killed many people and destroyed or damaged many buildings. Surprisingly it is still possible to see enough to imagine what an impressive place it was. Many repairs have been done and the outer town expanded greatly. Bhid gate is a fine example as it was badly damaged but now it looks the same as it was 20 years ago with its bustling market stalls. The classical style covered market has been restored and Saraf Bazaar subtly widened. The old centre is regaining its vitality and there is much to explore and enjoy. Even so it comes as a shock to see an empty tract of land where buildings have been bulldozed and a huge sign saying 'Earthquake Regeneration Zone'. Bhuj is not an obvious place and one has to seek out its treasures; the curator of the unmissable Aina Mahal is always willing to advise.

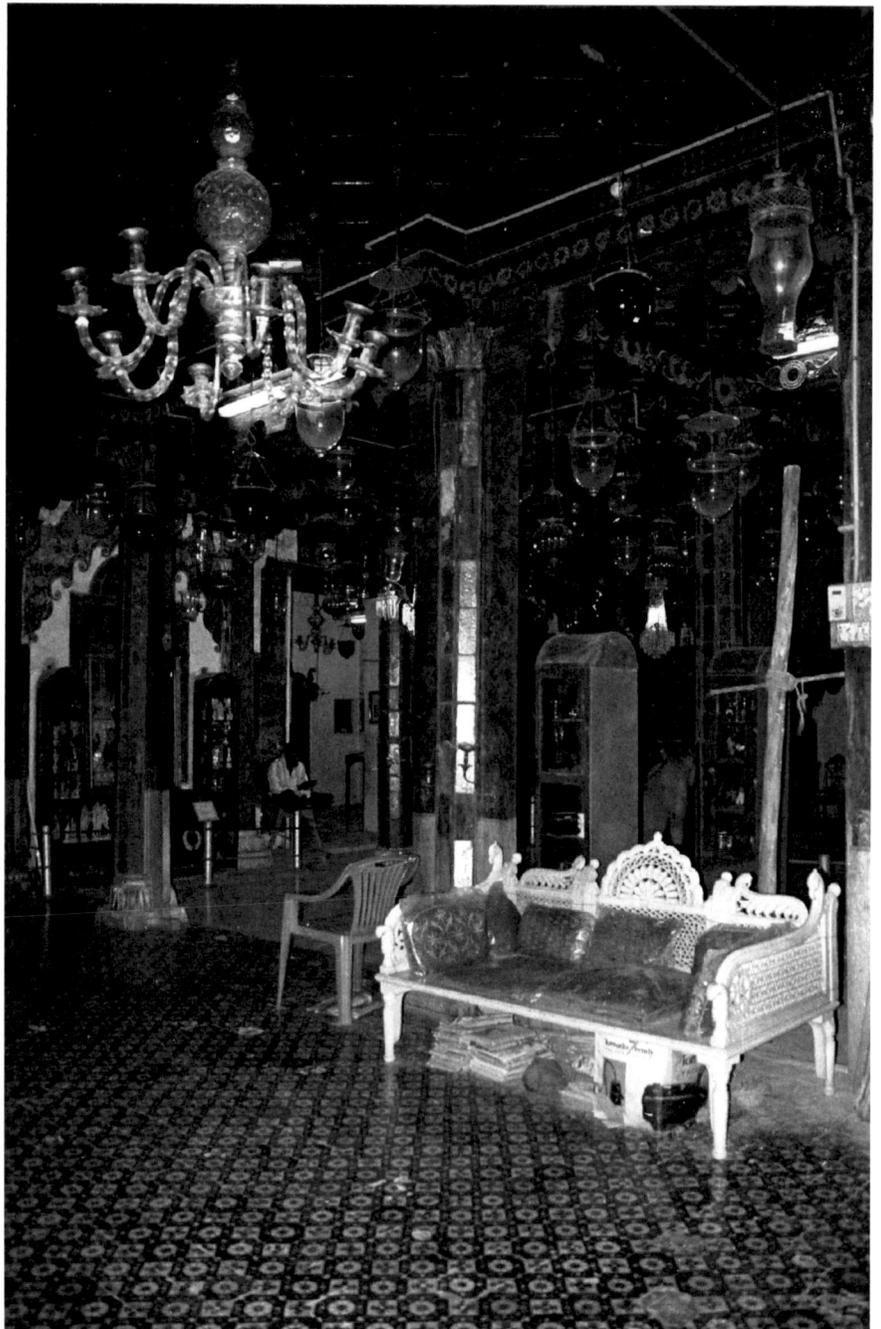

Bhuj, the Aina Mahal built in 1752 and now much restored.

A remarkable museum which has many works by Ram Singh Malam; a treasure trove.

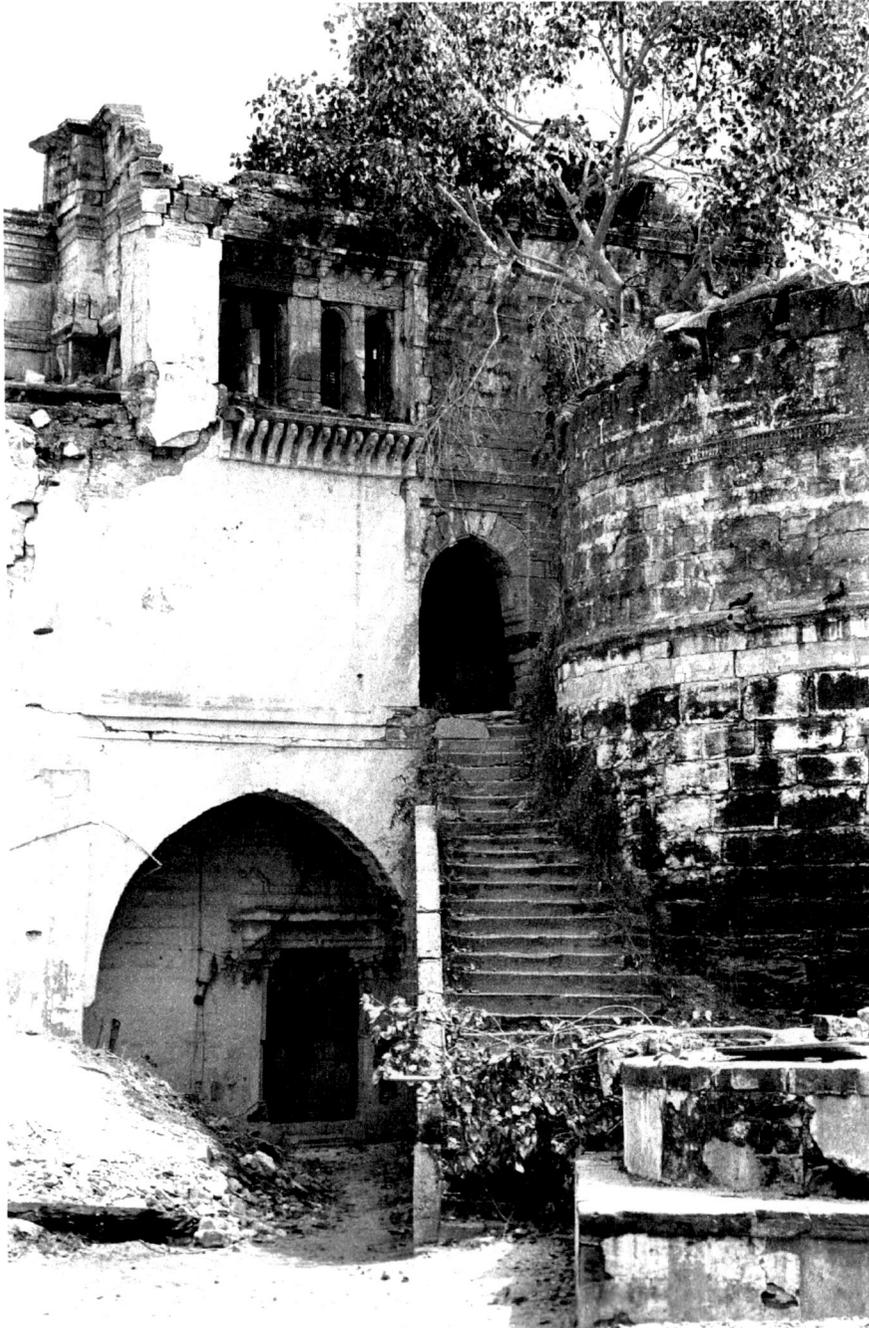

Bhuj, the Darbargarh courtyard.

The stairs led to the Accountant General's office, the adjacent archway to the *khili sthapna* and above were Khengarji I 's restrooms and a wrestling area.

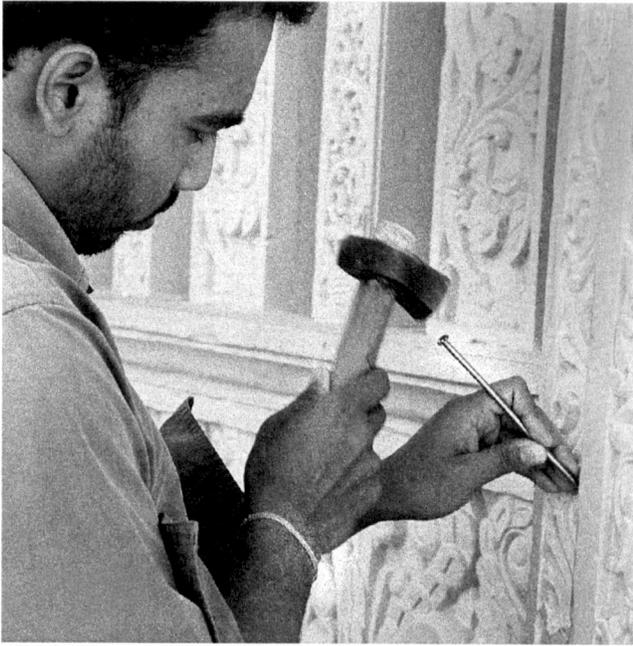
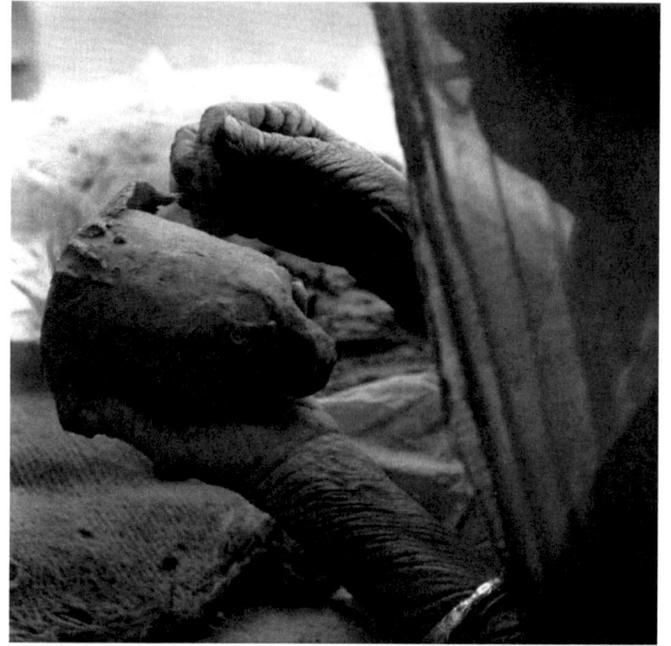
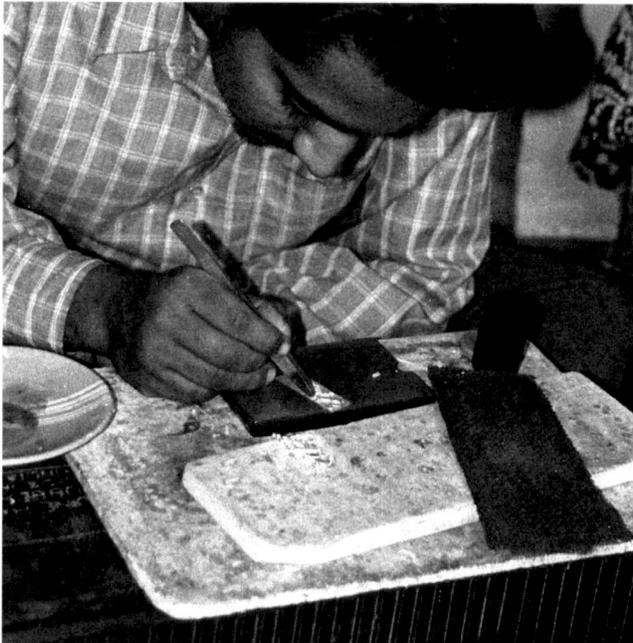
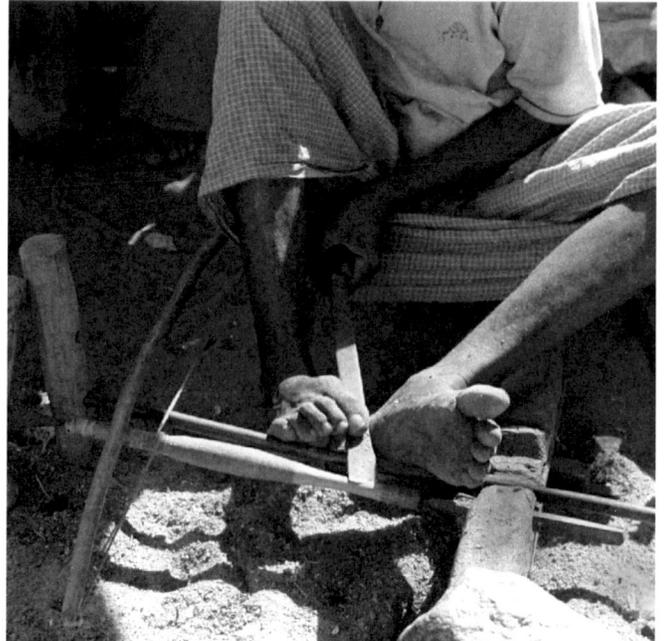

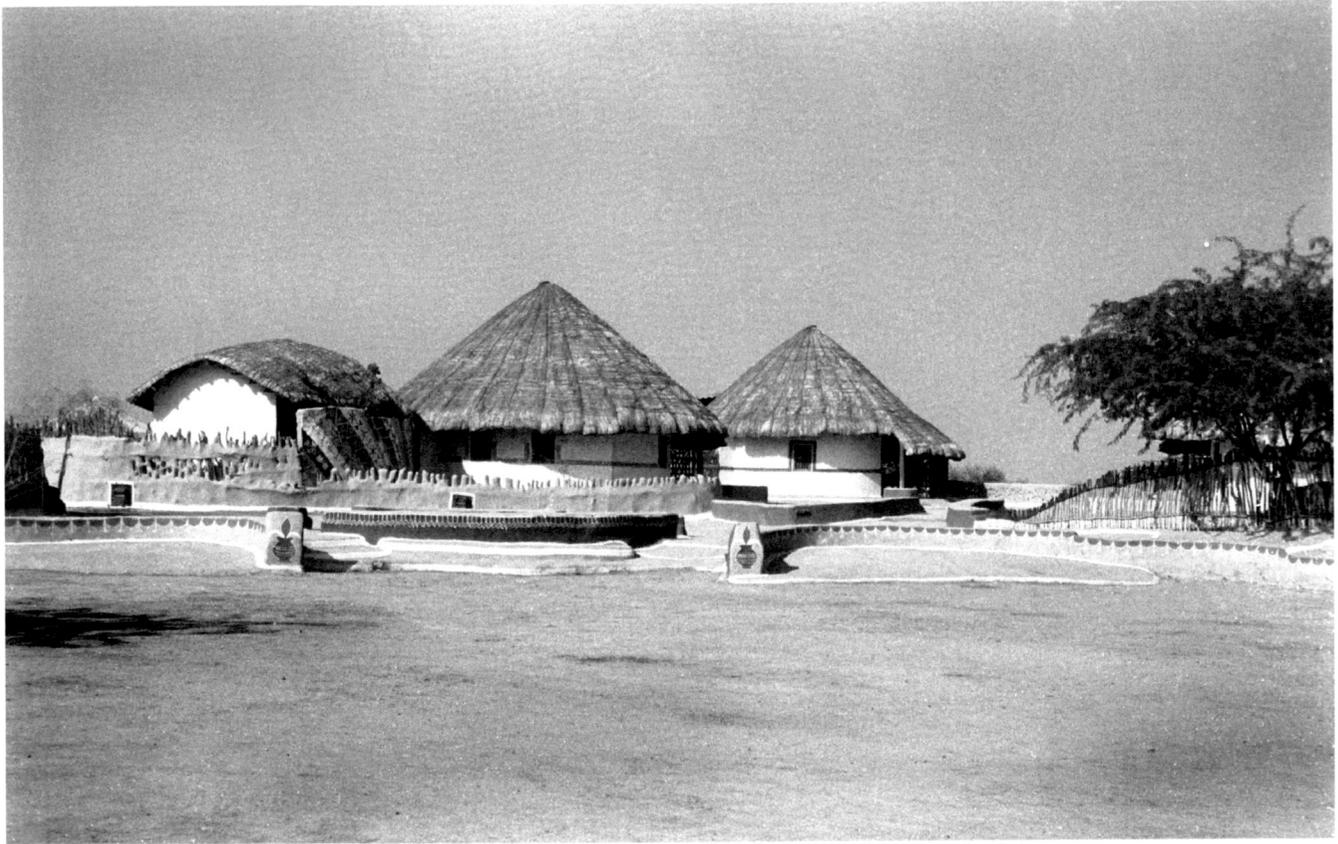

Crafts

Hodka lies north of Bhuj and is an excellent base from which to seek out various craftspeople in small towns and villages, and explore the Banni grasslands. There is great variety such as many types of textiles, embroidery, different uses of clay and plaster, ironwork, woodturning, leatherwork and pottery. Much has been written and illustrated elsewhere about this work, (see 'Suggested reading'). The following pages show a few places that took my particular interest.

Hodka, Shaam-E-Sarhad Resort.

An eco-friendly tourist development owned and managed by Hodka villagers.

(facing page) Other crafts: clockwise from top left.
Mata-no-Madh: finishing touches to Ashapura temple.
Zura: Bells made from hammered steel being coated in clay and borax before firing.
Zura: wood turner making handles for decorating with coloured lac.
Bhuj: Silversmith making earrings.

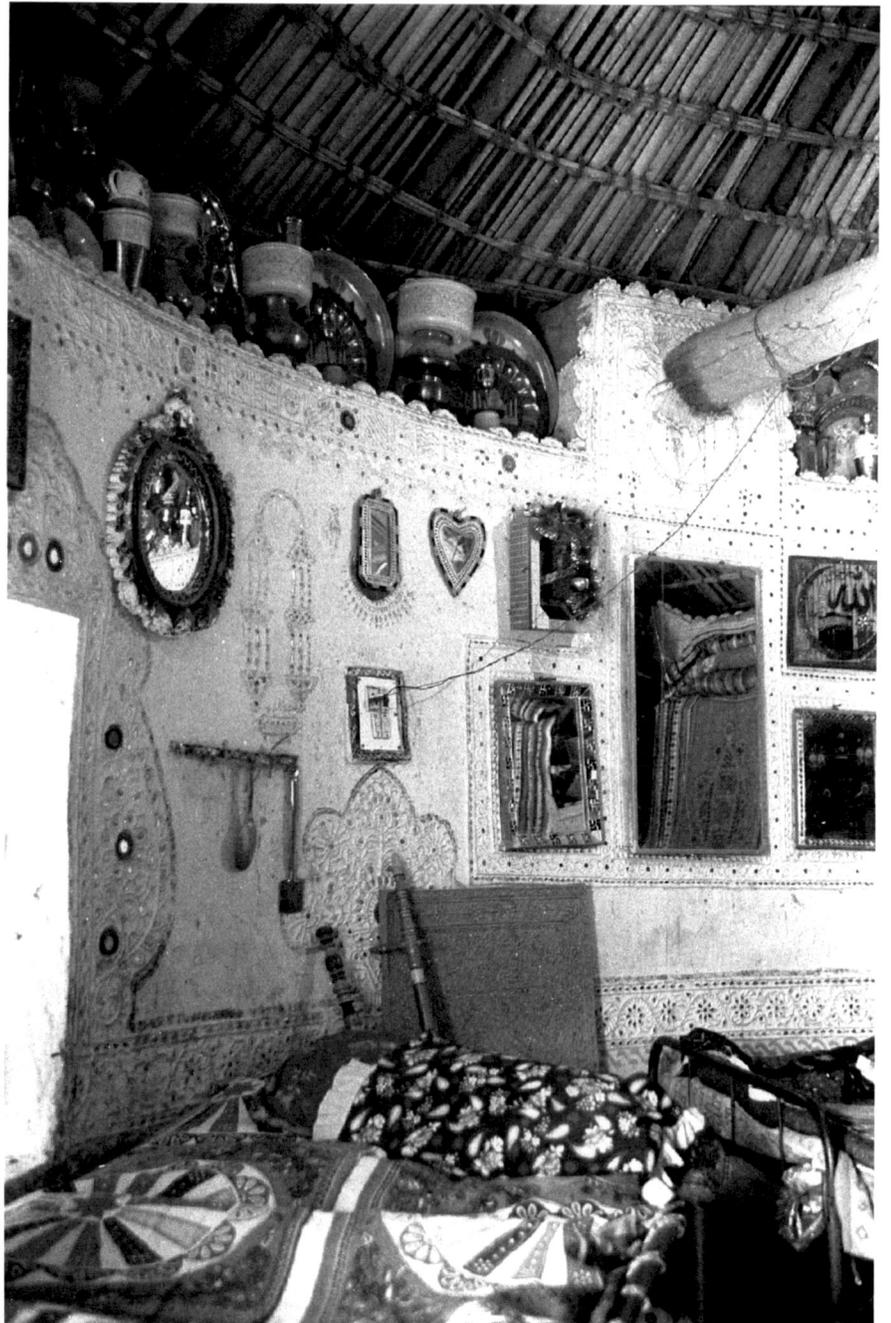

Dhordo, interior of a Bhunga decorated in
mirrored work by the master plasterer
Mahamood Mutwa.

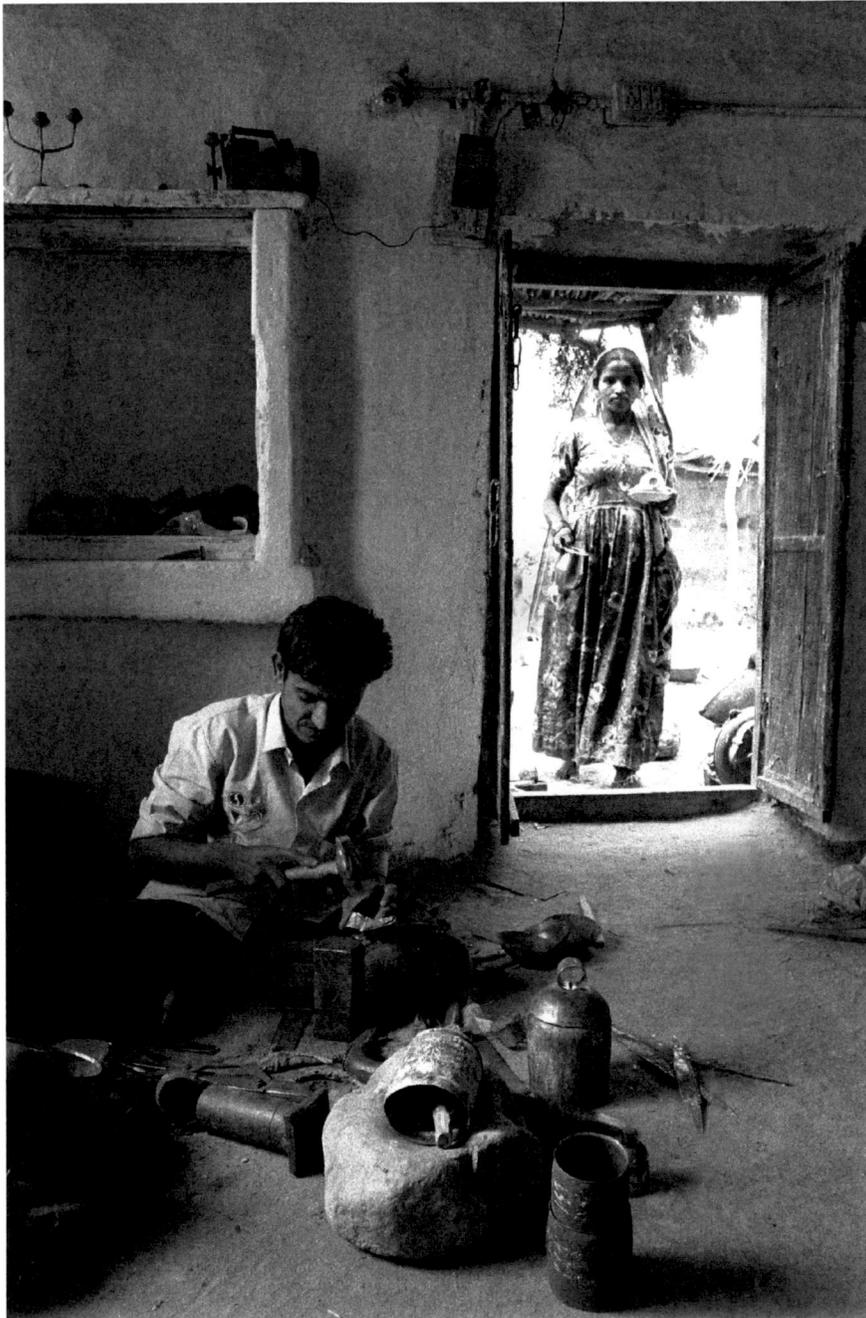

Near Mandvi, a bell maker and his wife.

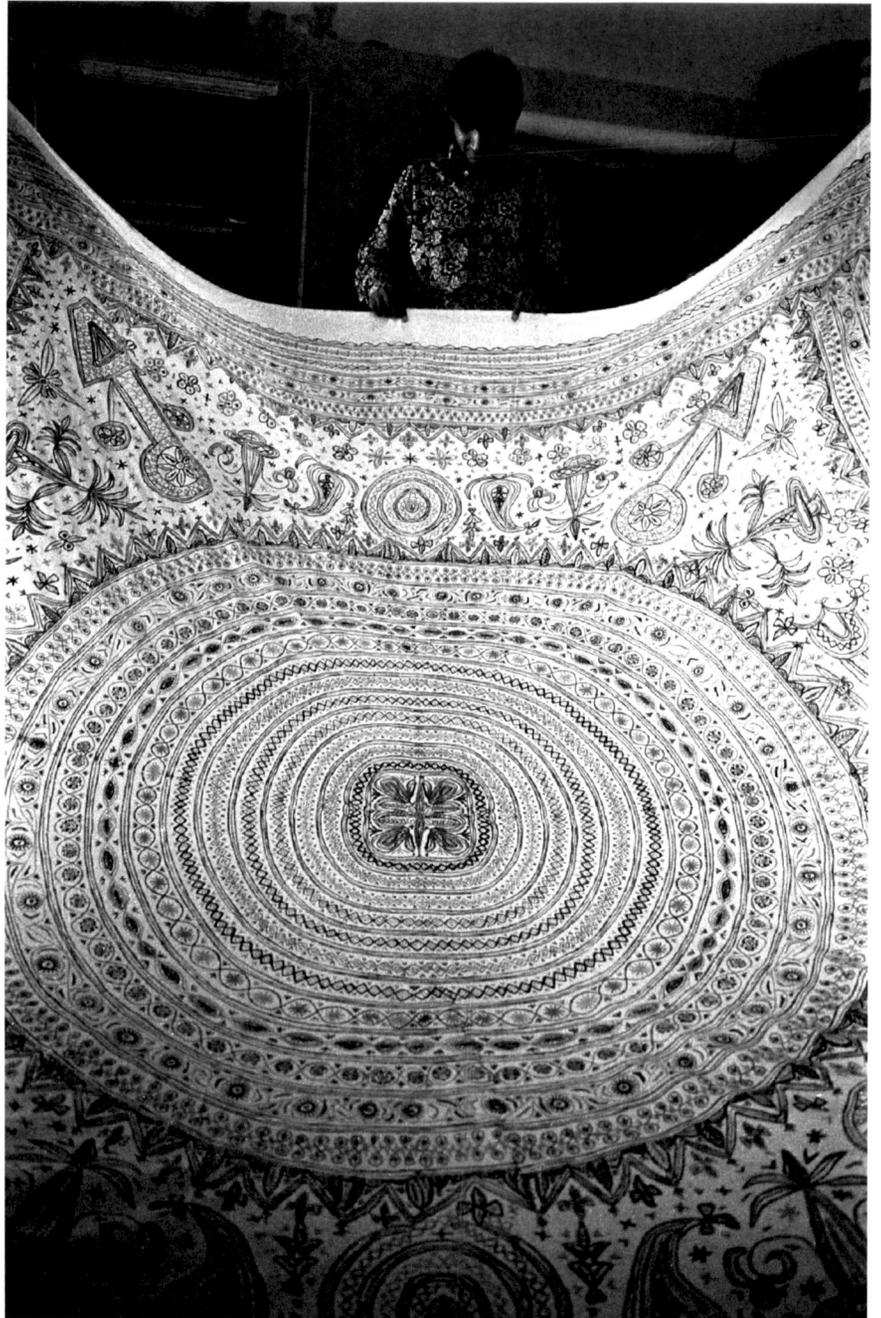

Nirona.

Rogan art is of Persian origin and the design is drawn entirely freehand by dragging fine pigmented gum made from castor oil plants. This piece is by Gafur Khatri who is concerned that this is a dying art.

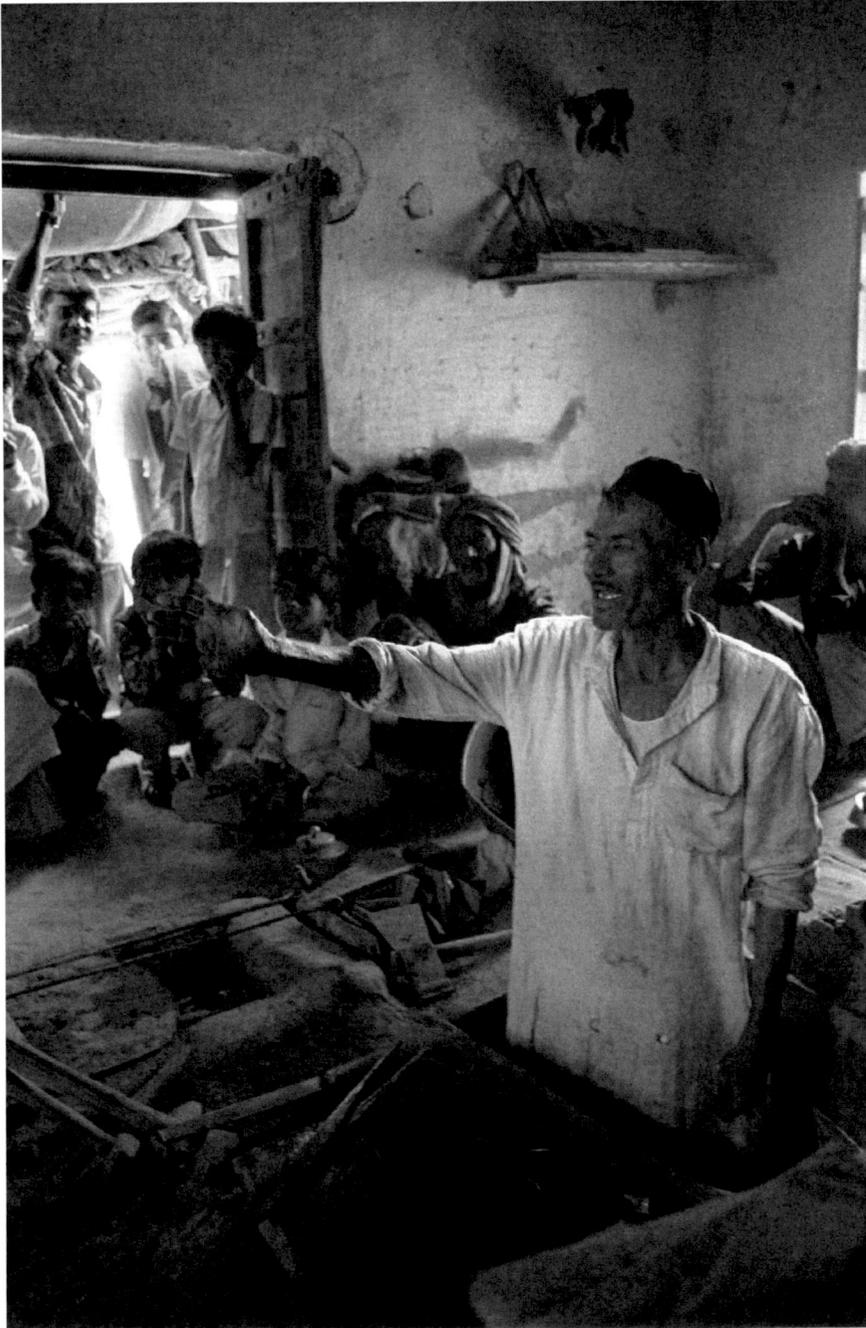

Near Mandvi.

The village metalworker attracts great local interest when his forge and huge bellows are in action.

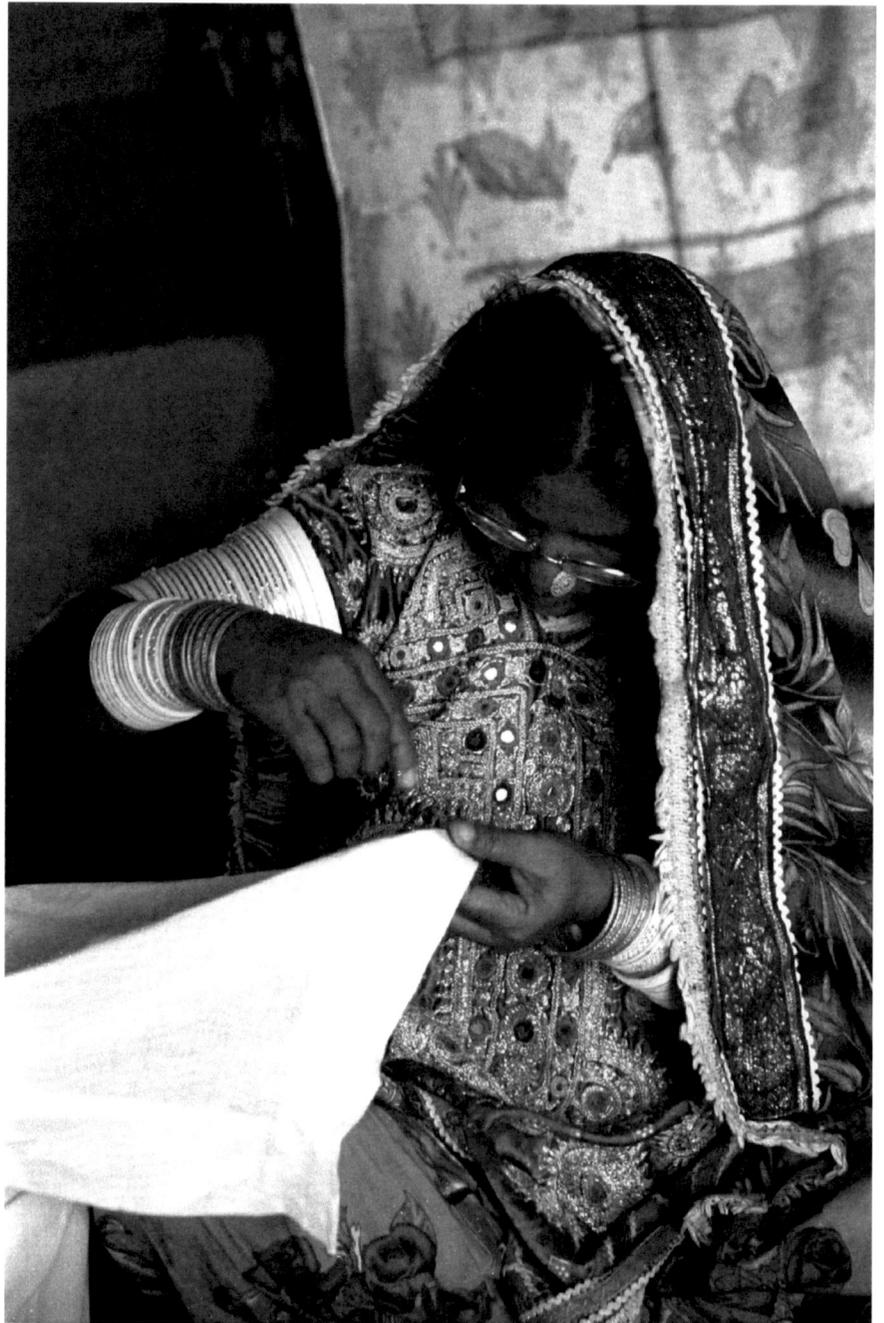

Hodka village.

Baiyaben, trying out a spare pair of cheap English spectacles on mirror embroidery, found that she could see clearly. It was a pleasure to leave them for her.

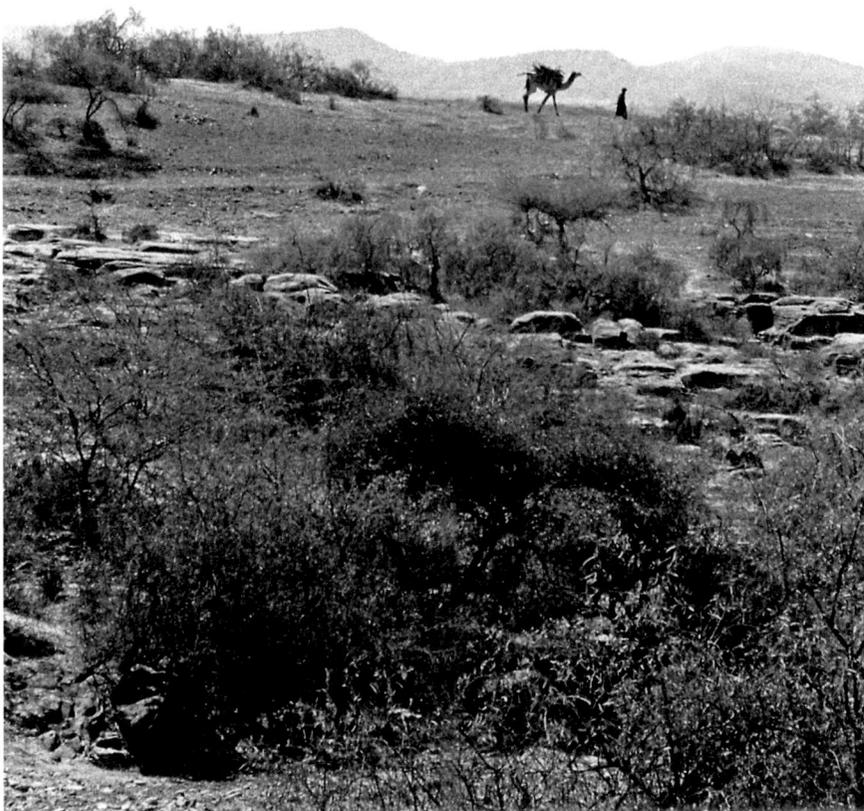

Kala Dungar (Black Hills).

Descending from the Indian military outpost and the temple at Dattatreya which overlooks the shimmering expanse of the Great Rann towards the Pakistan border. There is a new plan to fence off the last gap in the boundary, which is renowned for smuggling drugs, weapons and people, between the two countries.

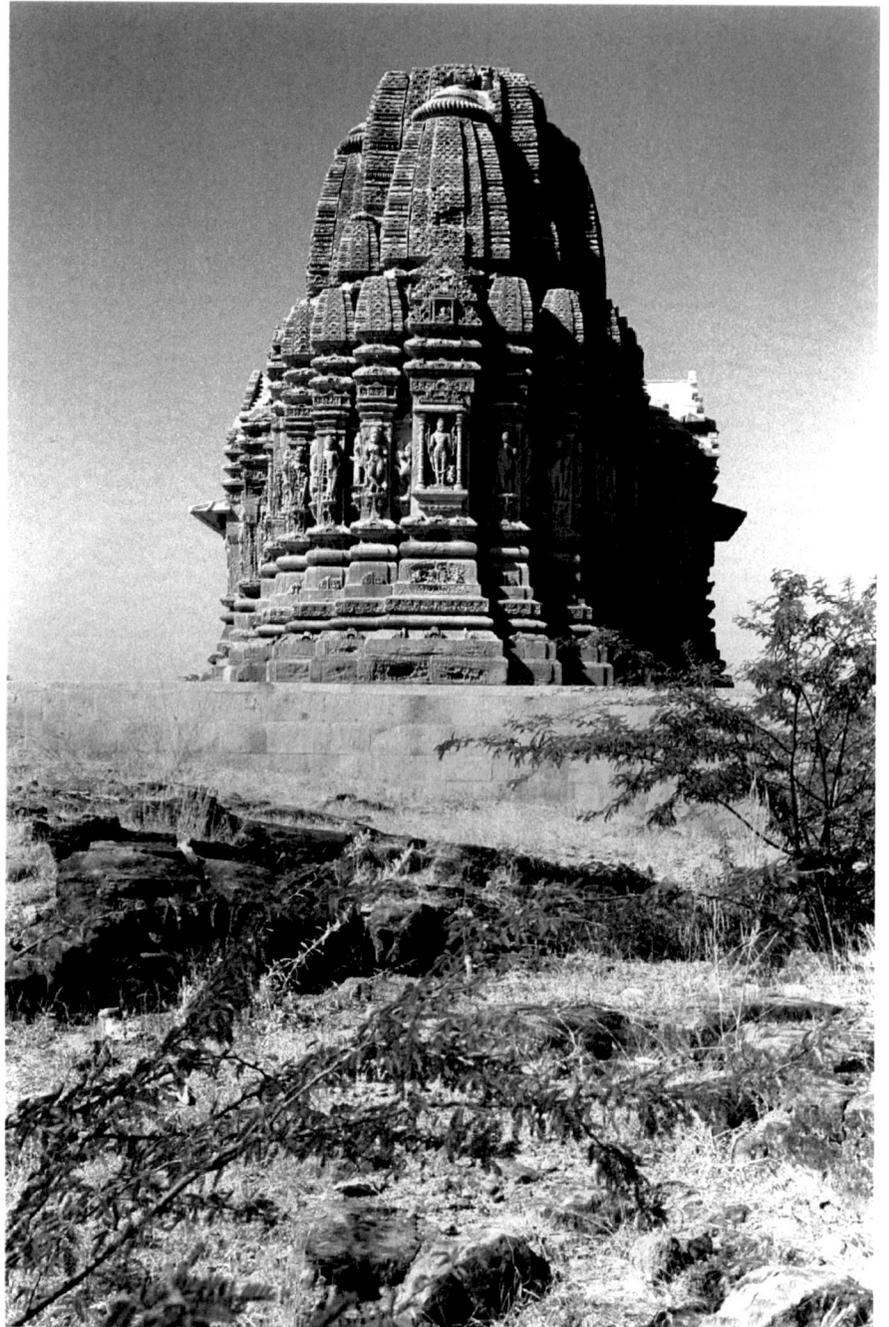

Kotai.

The restored Shiva temple is ascribed to
Lakho Fulani from the 10th century. One
of the few remains of an old city that now
stands lonely in the landscape.

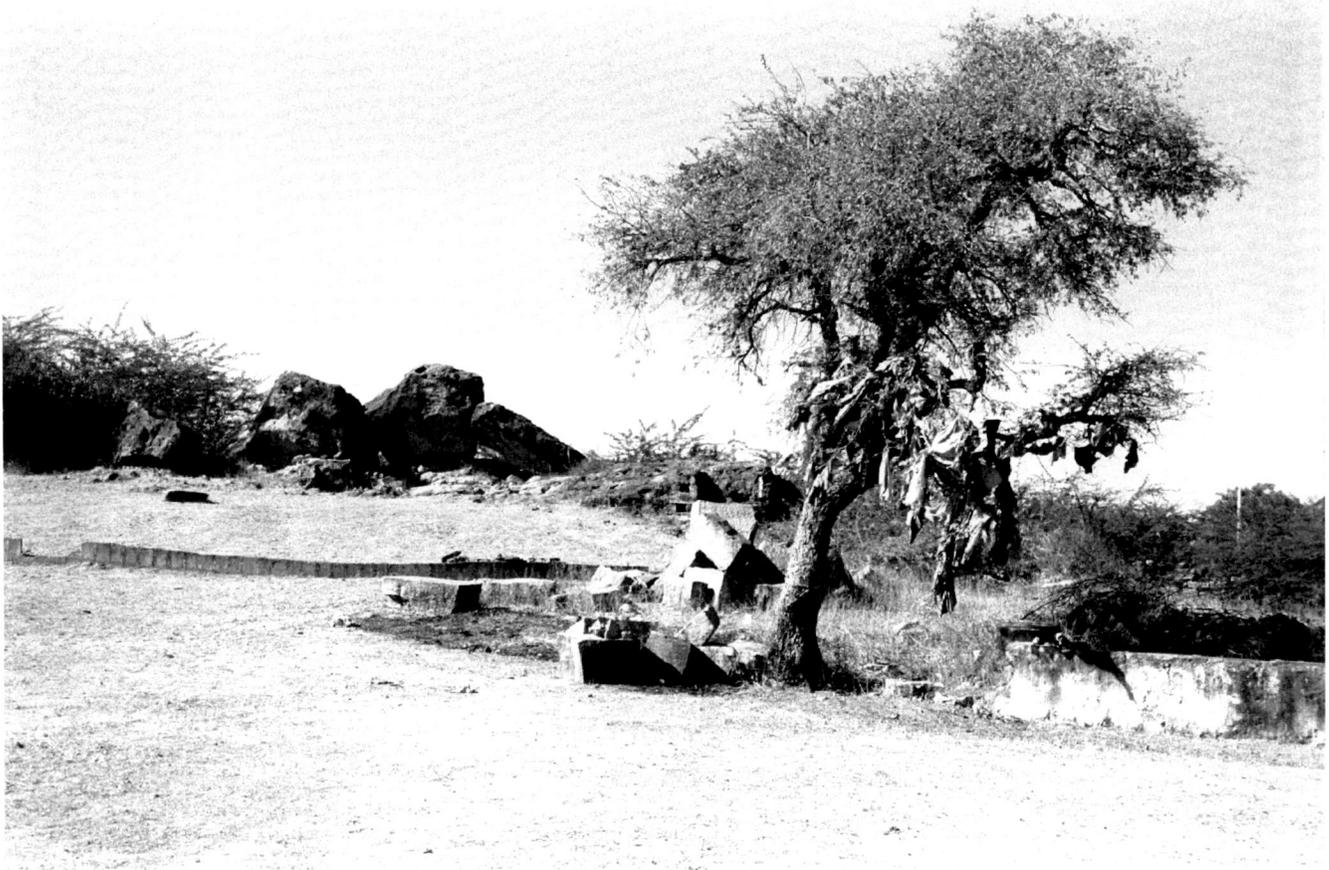

Kera.

A healing tree often found near temples. Mothers with ill children bring an article of clothing to hang on a branch and then walk seven times around the trunk. Kera was much fortified by Lakho Fulani in the 10th Century. Adjacent is a Shiva temple greatly damaged in the 1819 earthquake but fine carving remains inside.

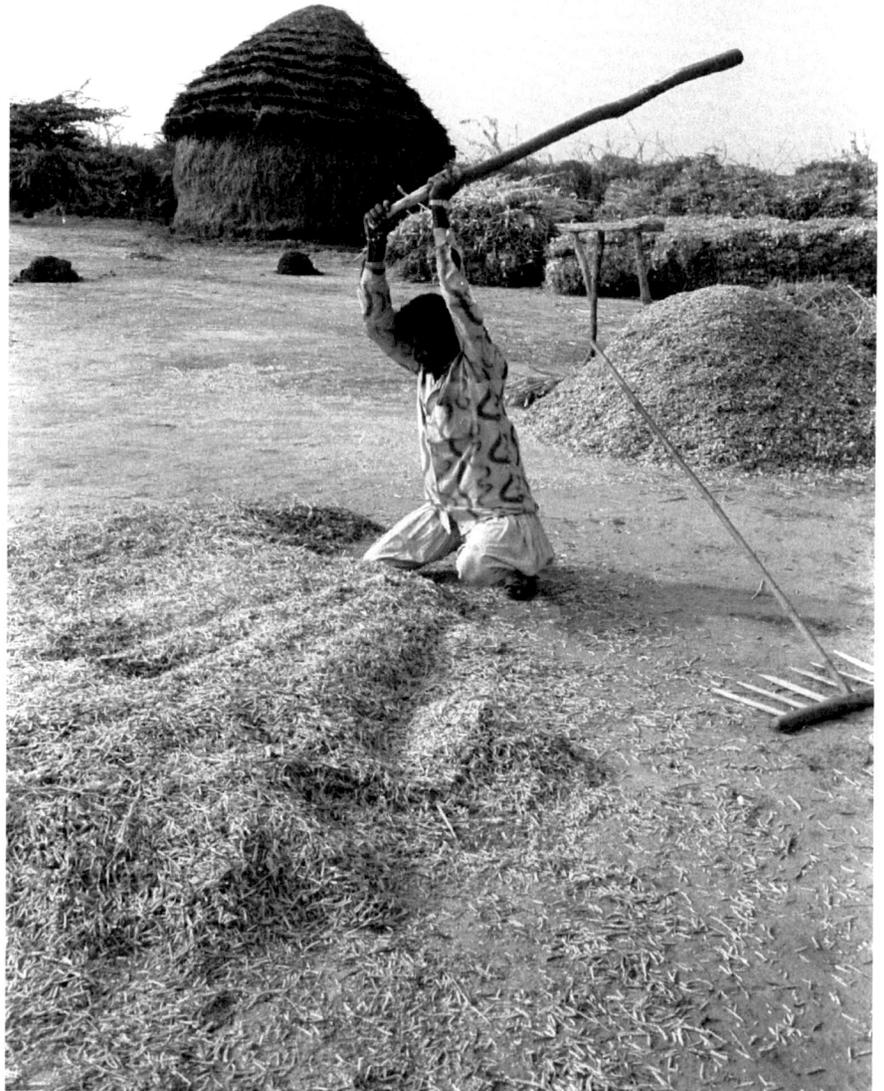

Near Rapar, traditional millet threshing.

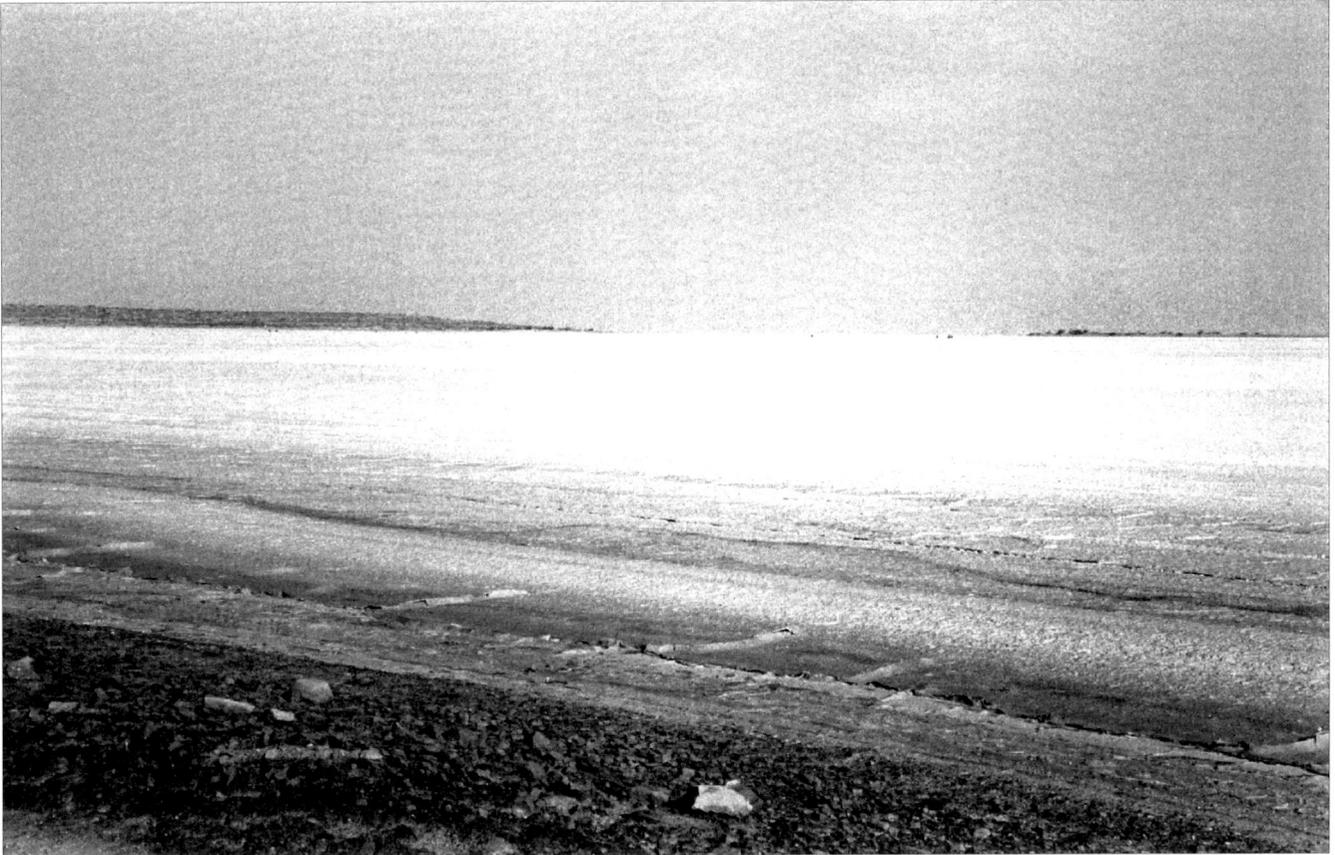

The Great Rann, from the causeway to Khadir Island.

Motorcyclists race their Royal Enfields on the hard salt in the distance.

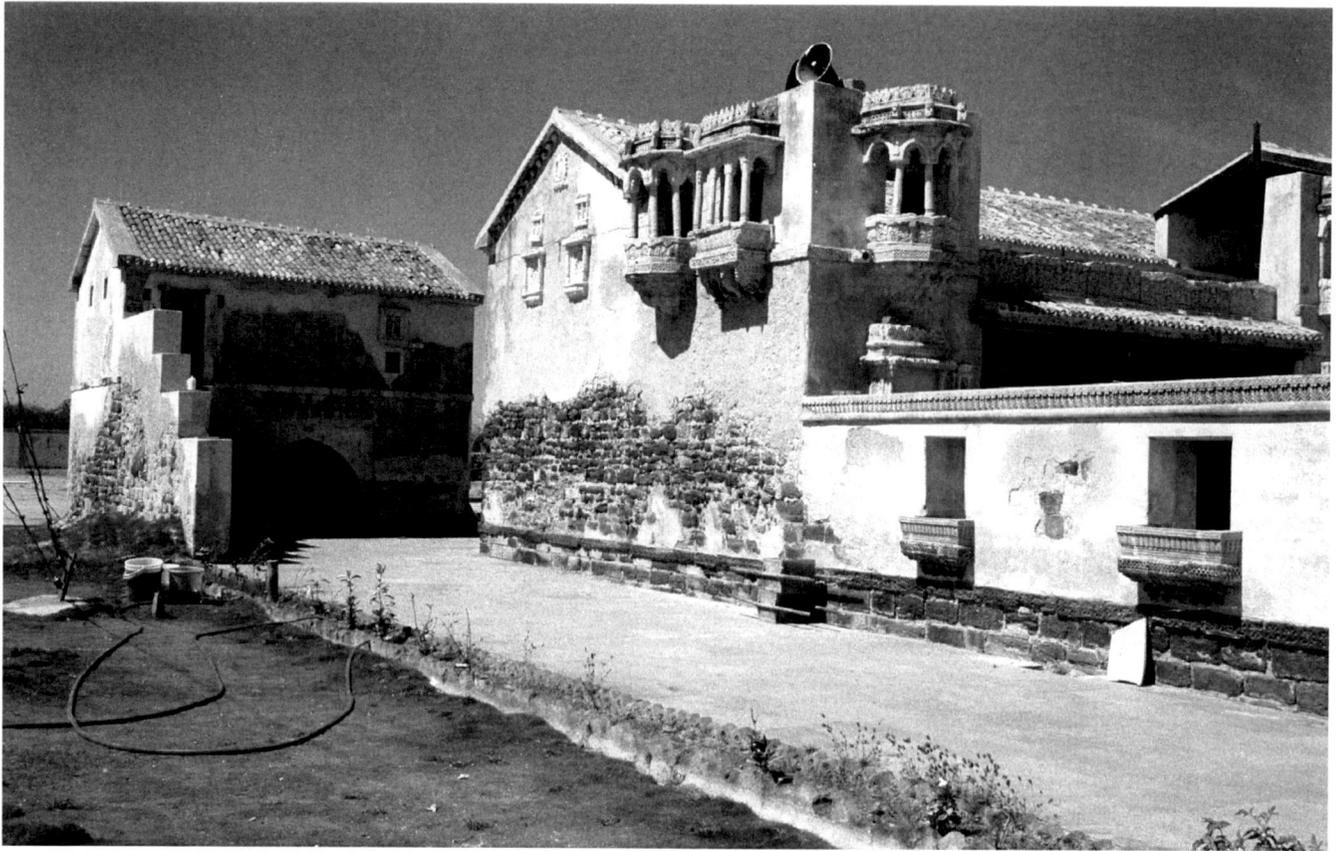

Lakhpat.

This was once a most important and wealthy
port but it was lifted 14 feet by the 1819
earthquake and trade went to Karachi. It
then dropped and was flooded by a tsunami
c1845. The vast and impressive fort walls of
1786 survive and a few fine buildings. One
is the early-nineteenth-century Gurudwara
Pehli Patshahi, which is much revered by the
Sikh community as it was built to commemo-
rate the visit in 1506–1513 by Guru Nanak,
the founder of Sikhism. It received a Unesco
Conservation Award in 2004.

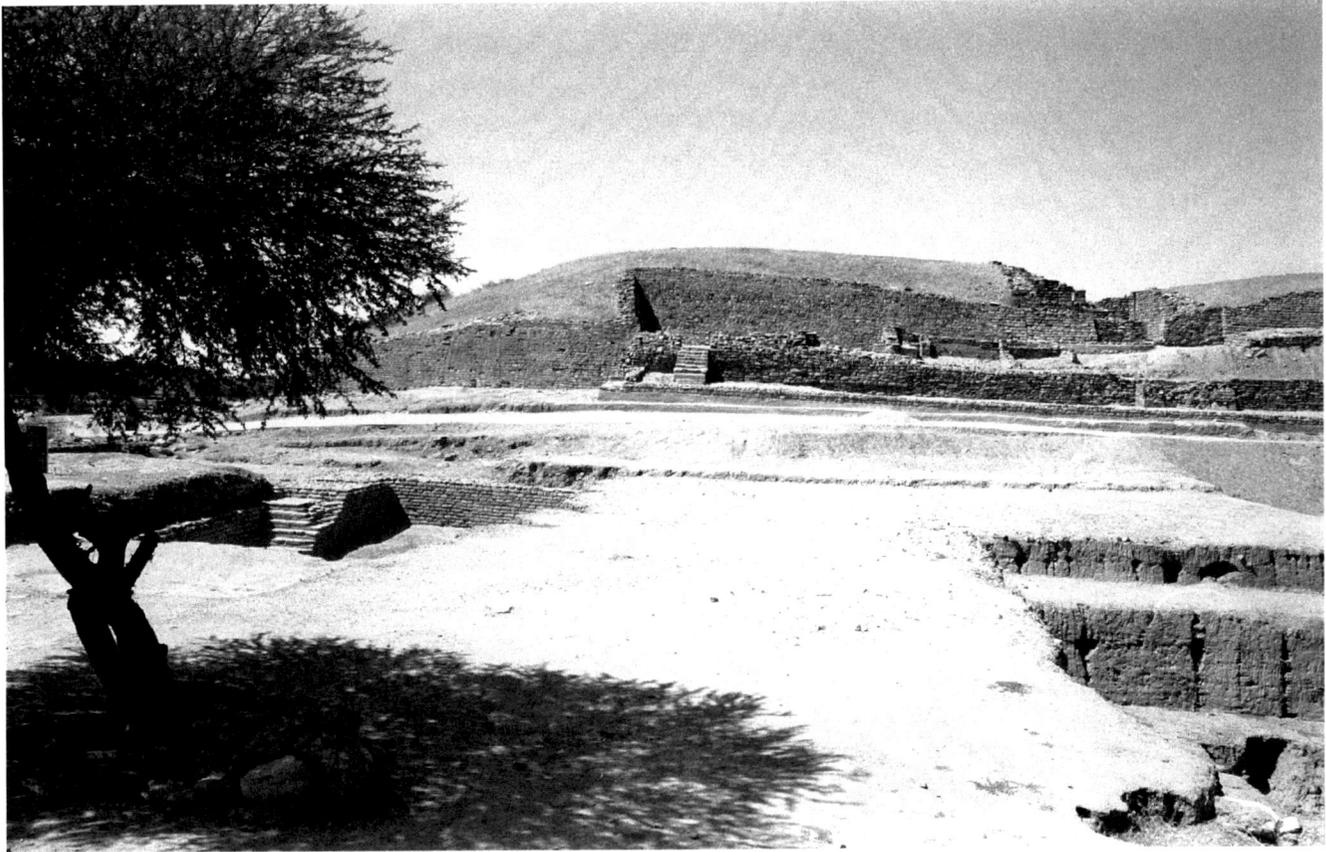

Dholavira on Khadir Island, the citadel and the east gate. Part of a large tank is on the right.

Discovered in 1967 this is one of the top five cities from the Indus Valley Civilisation. Once a major port it has a citadel, stadium, an upper and lower town, 16 reservoirs, and a sophisticated drainage system. It extends over 100 hectares and excavations continue.

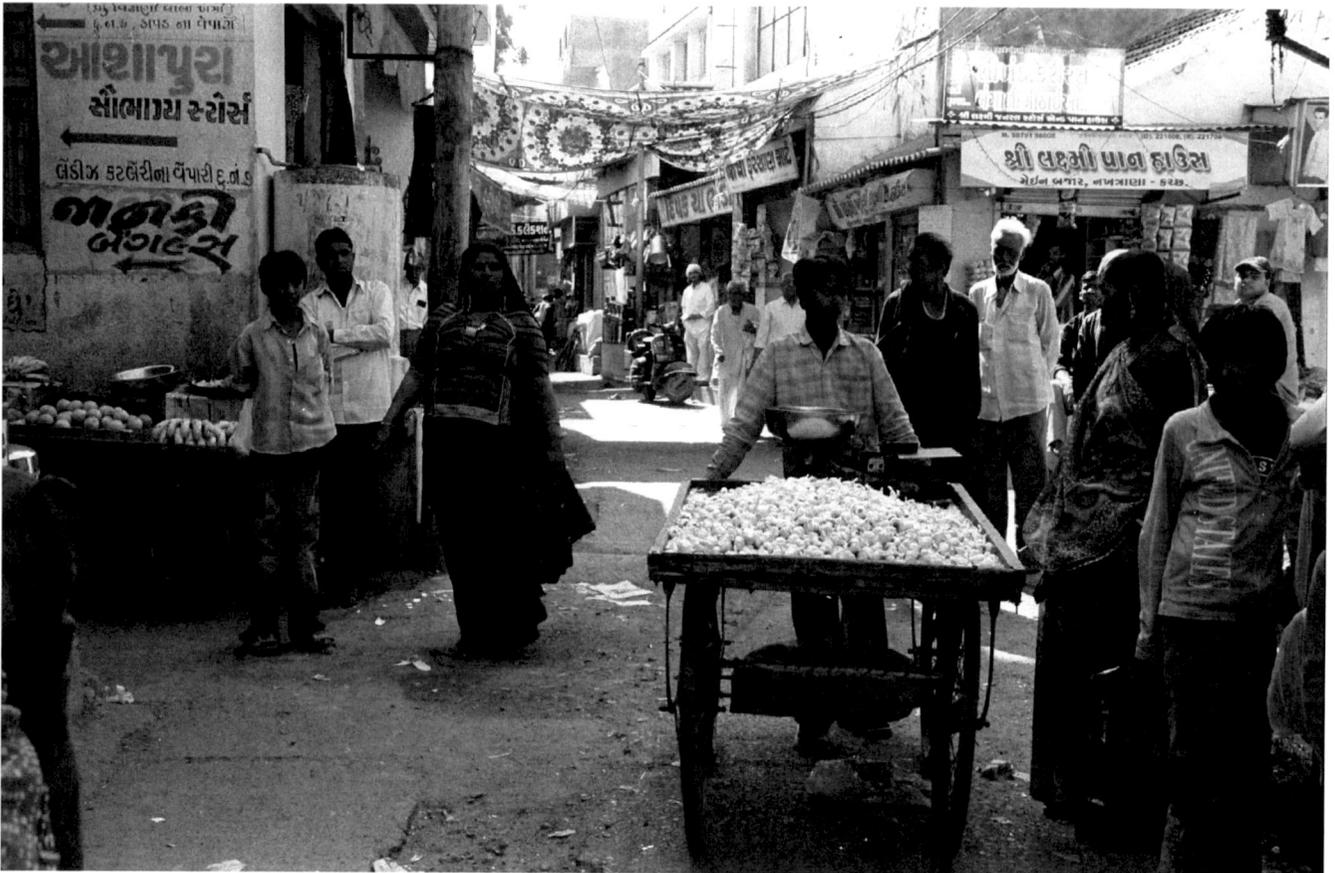

Nakhatrana, garlic seller in a shopping street
that is typical of Kutch.

People and ethnic communities

The total population has increased by an astonishing 32 per cent in the last ten years. The 2011 census gave a total in excess of 2m compared with 1,583,000 in the census of 2001. There are three main reasons for this: Gujarat's objective to increase industry so attracting migrant workers, for example, from the poor State of Bihar, to work in the big ports; government tax relief after the last earthquake, and in rural districts the lack of family welfare. The State's policy for rapid growth has a worrying impact on fragile traditional communities, reliant on pastoral farming.

The census gives the population density as 46 people per sq. km. which is very low compared with India's average of 368. However, it seems that the uninhabitable Ranns have been included, so the density is still low at about 130 per sq. km. The census reveals that about one third of people live in towns and the rest in rural areas. The literacy rate particularly among children has increased to around the national average of 71 per cent, but there is a need for improvement in a full education.

Though mainly Hindu there is an average of 21 per cent Muslim people, which is 10 per cent more than India's average. Generally the two peoples coexist well enough in spite of a few past notable exceptions. There are no indigenous tribal people in Kutch apart from some settled Bhils. To the visitor there are interesting ethnic communities and a few are shown on the following pages.

A selection of people one might meet including a teacher, banker, monk, transvestite, textile seller, restauranteur, boatbuilder, master plasterer, farmer, rickshaw driver.

Ahir people

This ethnic group which claims to be descendants of Lord Krishna is spread widely in northwest India and four communities settled in Kutch. In the 12th century a major clan of Rajputs fought at Daneti, hence the hero stones, and now Ahirs live here. They have established a well-known centre for embroidery. The dress is distinctive as young women wear highly decorated skirts whereas older women have plain black skirts and simple bright panelled mashru blouses. Single ivory bangles are often worn by older women but these are being replaced by resin. Young women are reluctant to wear these at all.

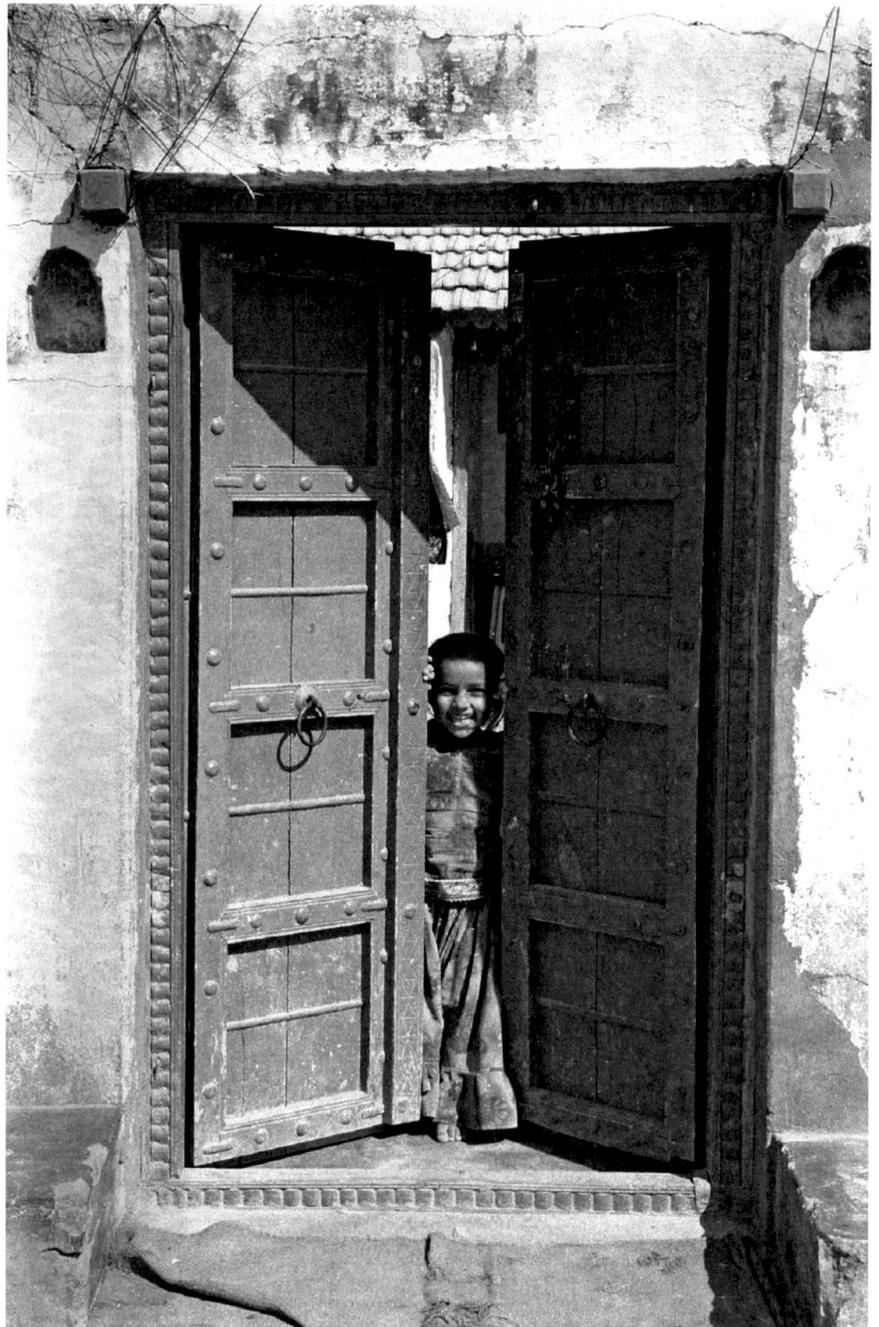

Daneti, an Ahir girl at a courtyard house in the old village.

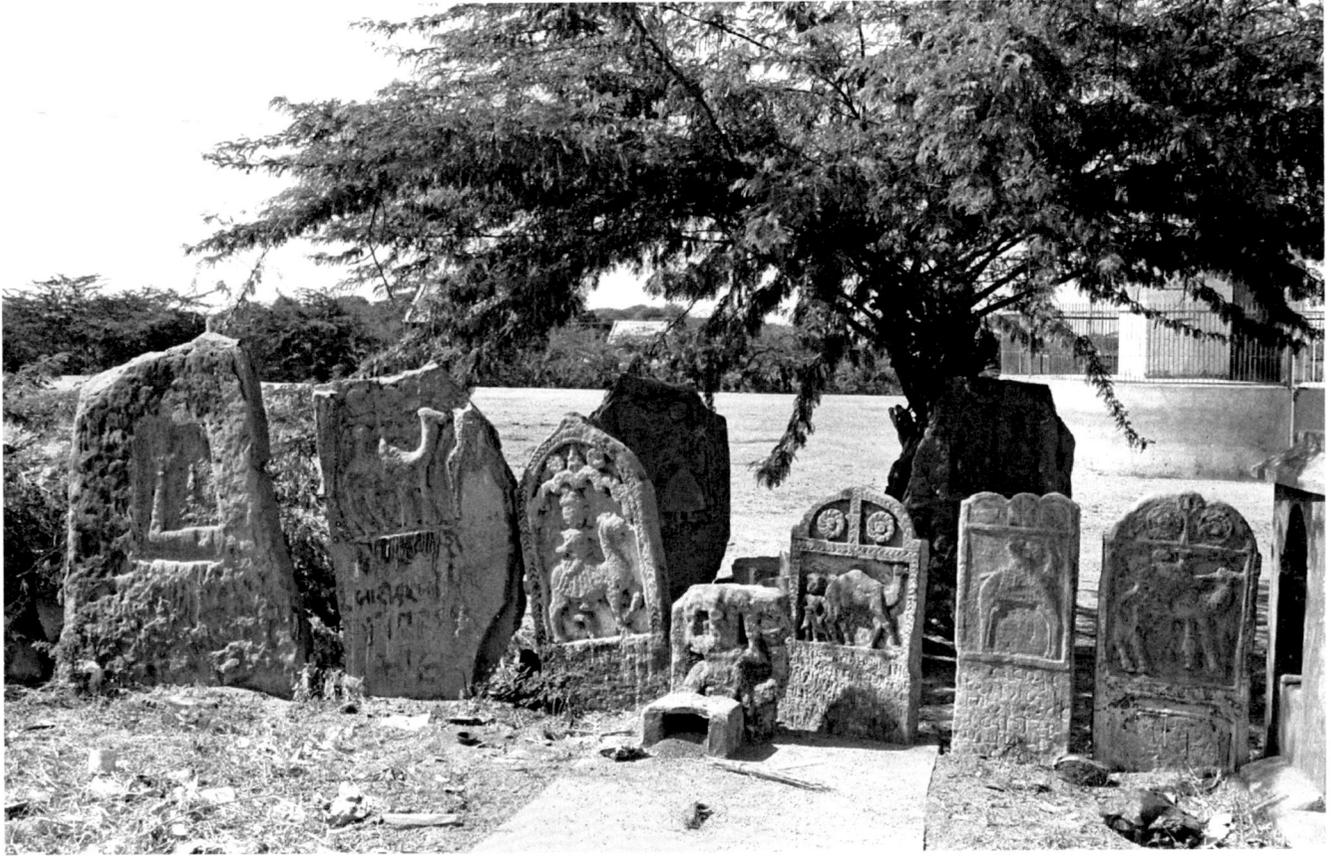

Paliyas, hero or warrior stones near Daneti.

Erected to commemorate the dead, usually freestanding and unrelated directly to any burial. The location is often near the scene of battle and many are ancient. The sole upraised hand symbolises a wife who has committed sati.

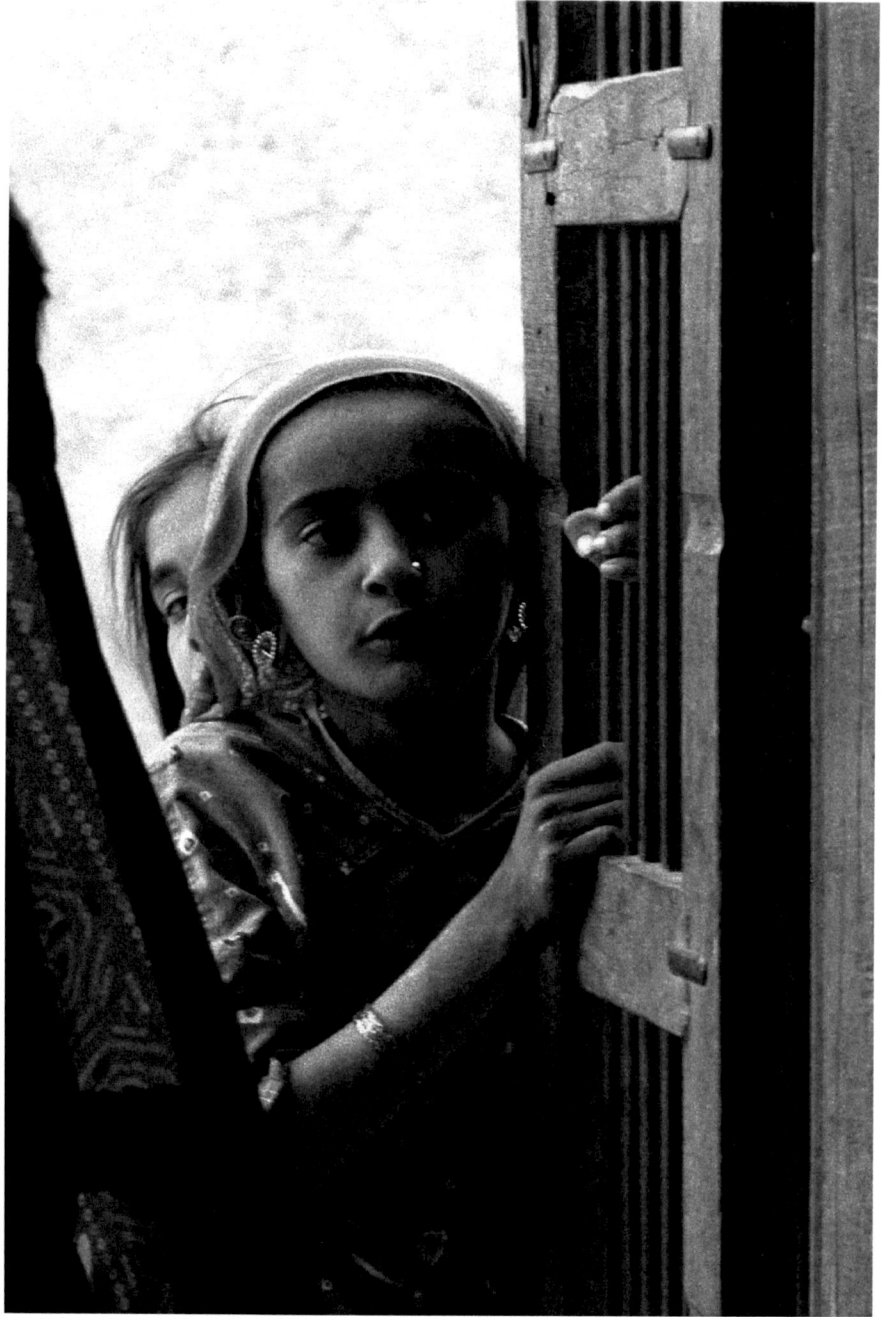

Near Mandvi, Ahir girls.

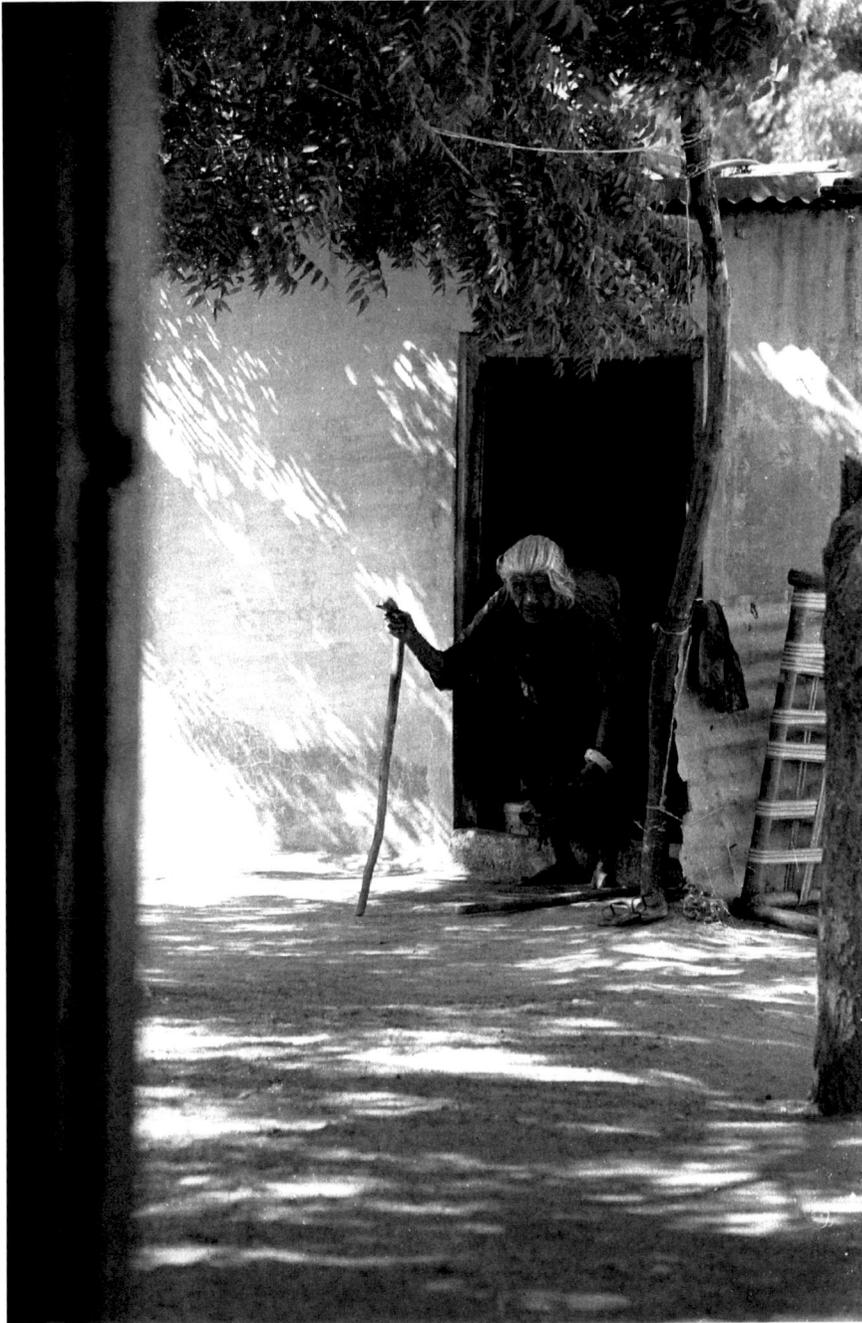

Ratanal, an Ahir woman with a typical ivory bangle.

This large town is known for its high proportion of lorry drivers and its high percentage of widows.

[41]

Jat people

The Jat(h)s of Kutch are entirely
Muslim and believed to have come
originally from Halaf in Iran about
five hundred years ago. They are
not to be confused with Hindu Jats
from Haryana and Punjab although
some say there is a link. This cattle
breeding community is likely to have
migrated from Sindh and still retains
a strong individuality. There are three
groups. The largest and main group
are Dhanetahs who continue cattle
breeding, mainly buffalo. In the north
near Lakhpat are the Garasia who are
shepherds. The poorest and smallest
group are Fakirani Jats who are
nomadic holymen and beggars.

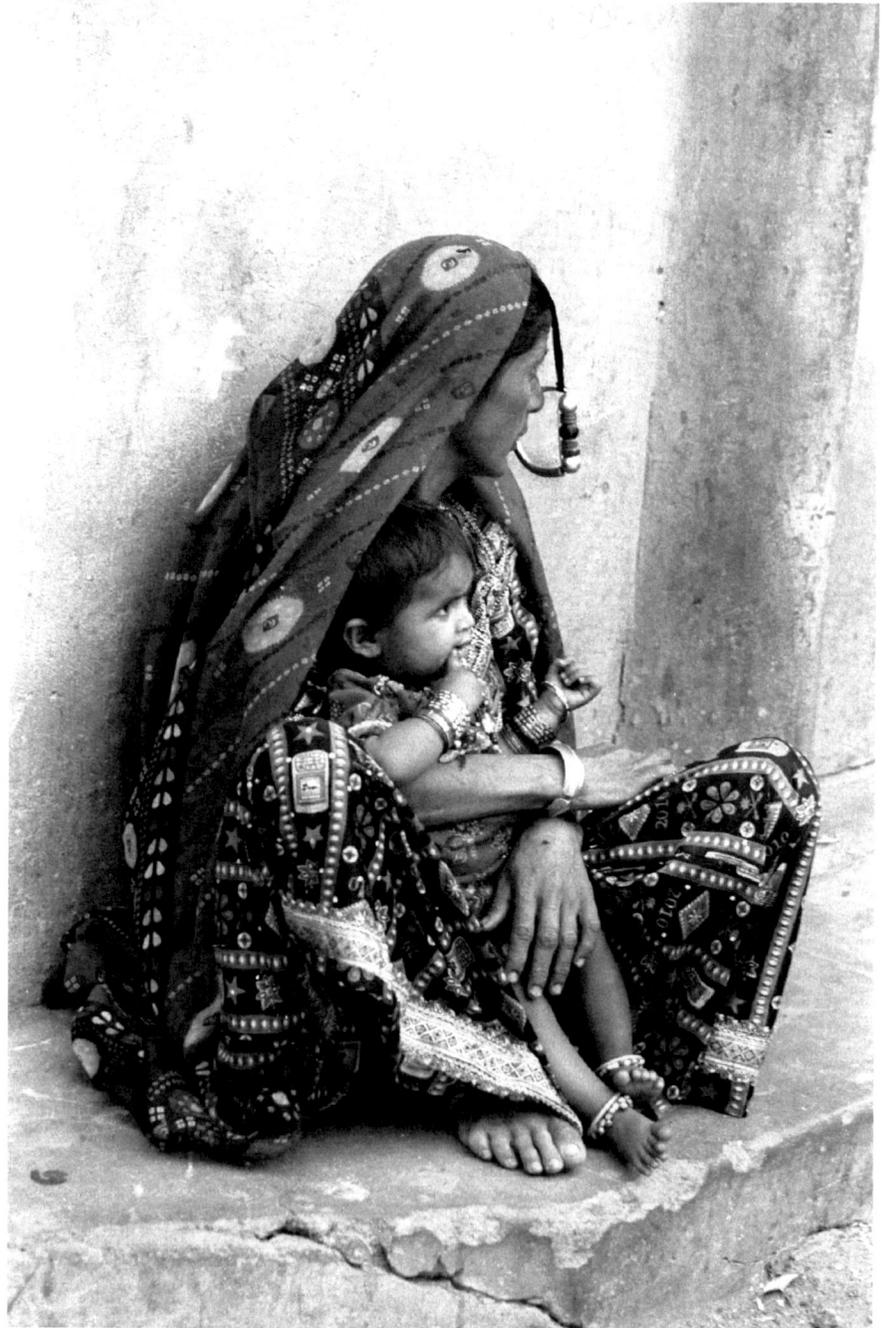

Bhuj, Jat mother and child waiting for the
village rickshaw.

Sadhai village.

The huts are on raised ground and some bedroom areas are on stilts as the village floods in the monsoon which brings out water snakes.

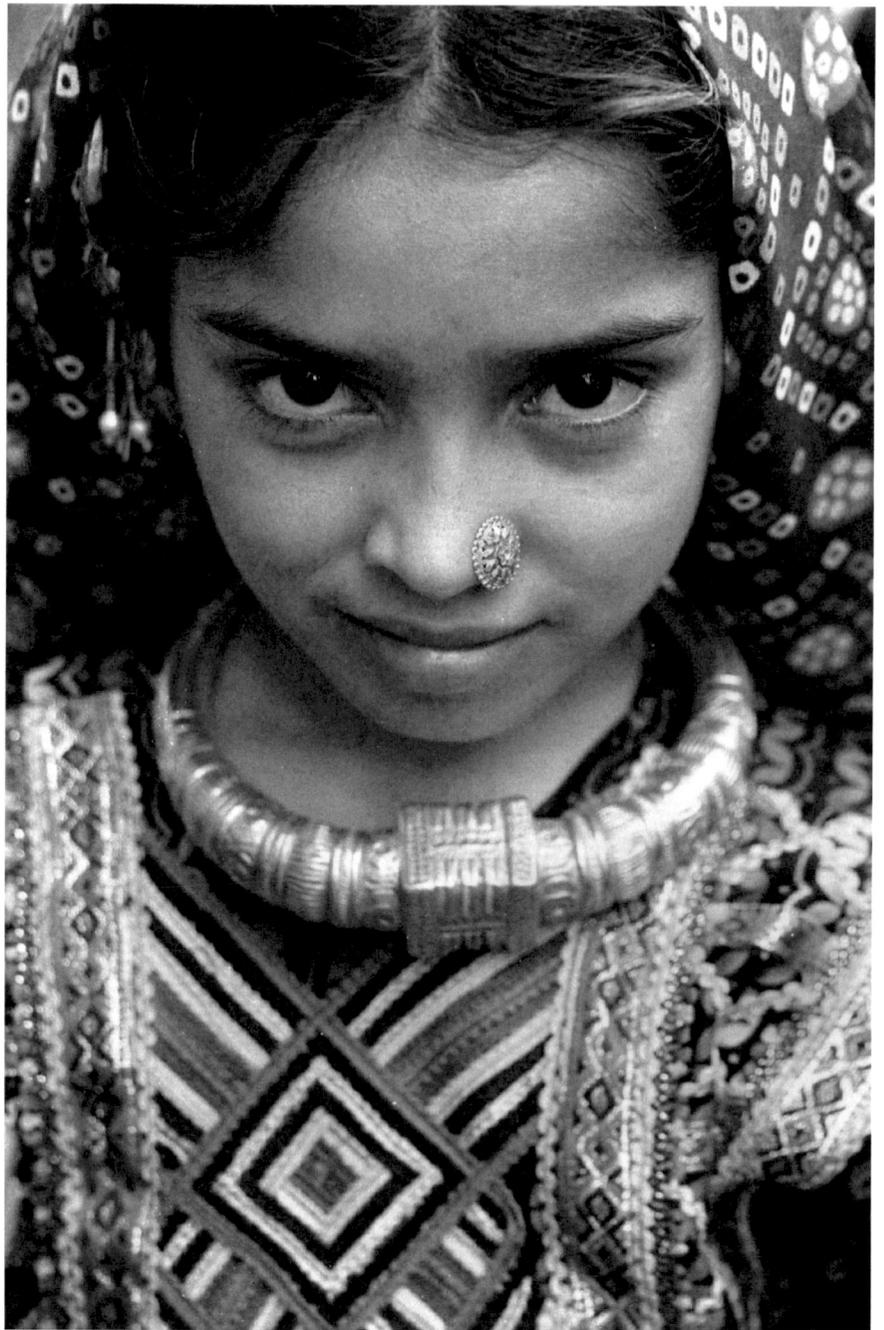

Bhuj, a young Jat girl with a typical torc and pierced nose which becomes enlarged before marriage.

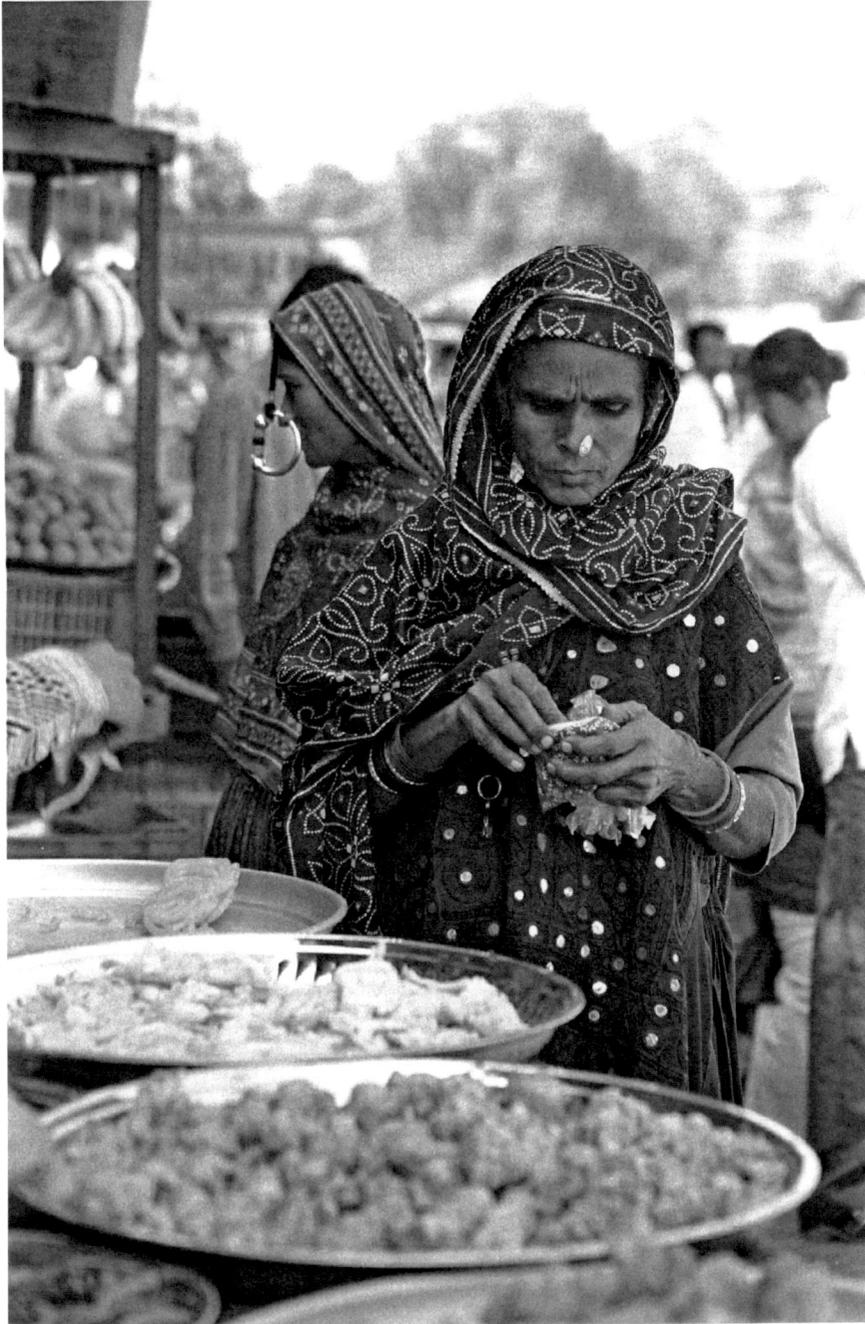

Nakhatrana, Jat women at a pakora stall.

The distinctive golden and bright glass nose rings signify marriage.

Harijans and Meghwals

The Harijans were untouchables until Mahatma Ghandi gave them this new name meaning 'God's people'. They are often associated with Rabari people who spin their own thread and the Harijans weave it, wash it and have it dyed ready for the Rabari's very distinctive styles of embroidery. Bhujodi, has many Harijans and is considered to be one of the best of many weaving villages in Kutch. Whilst Rabari work is on the decline the Harijans are doing big business with wool shawls and are known to employ their Rabari caste superiors.

The Meghwals are Hindu and migrated from Rajasthan to Sindh in the 17th century. After Partition many moved south to Kutch where they diversified and are now farmers, carpenters, tailors and weavers. In dress and custom they are similar to the Harijans.

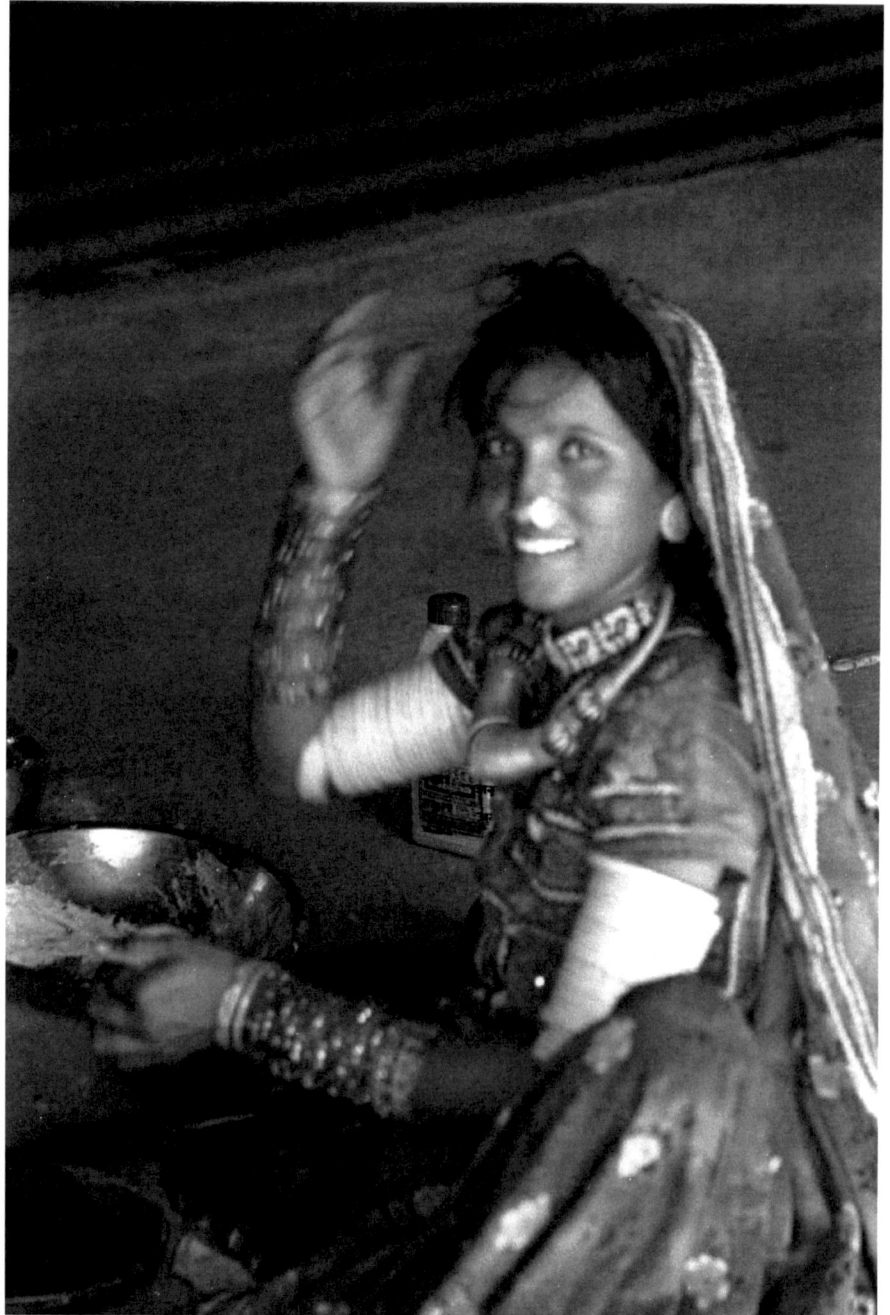

Ludiya. The fastest chapatti maker in Kutch.

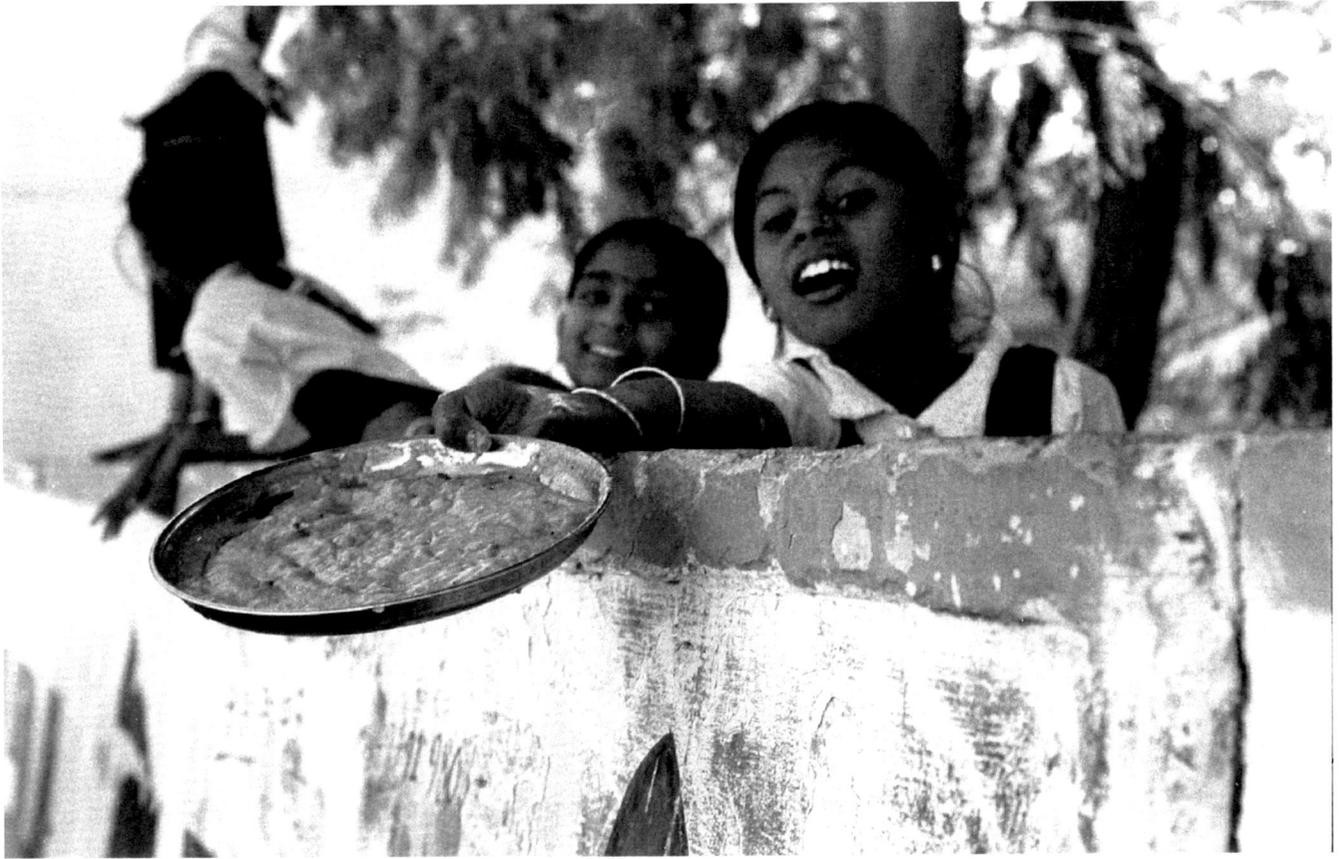

Bhujodi, schoolgirls in this village of weavers.

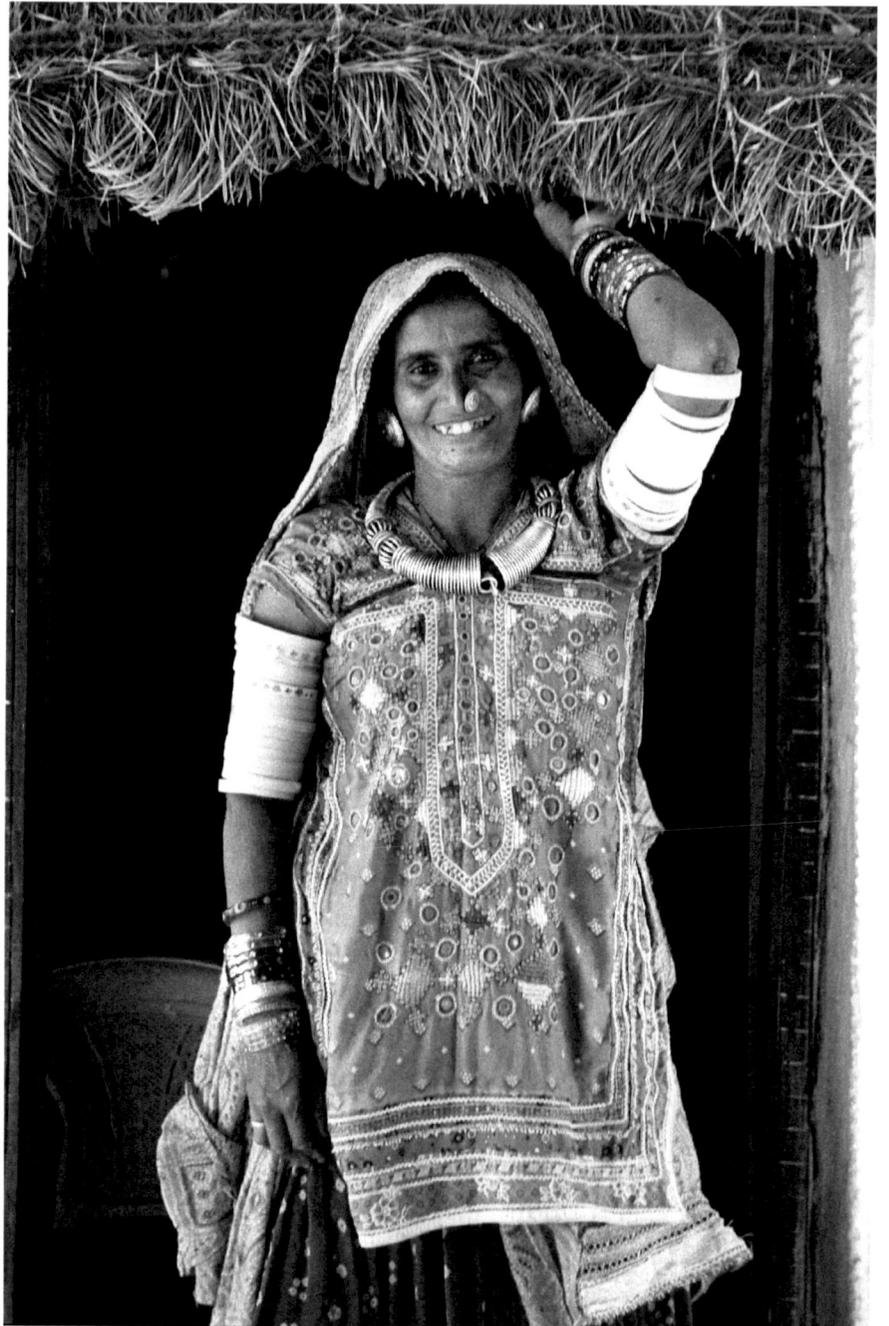

Ludiya. Viraben

Any visitor to Ludiya will hardly fail to meet Viraben, a Harijan in typical dress, and listen to her persuasive cheerful chat. She always has something to sell which is hard to resist and you know when you are near the right price when she calls her husband on her cell phone.

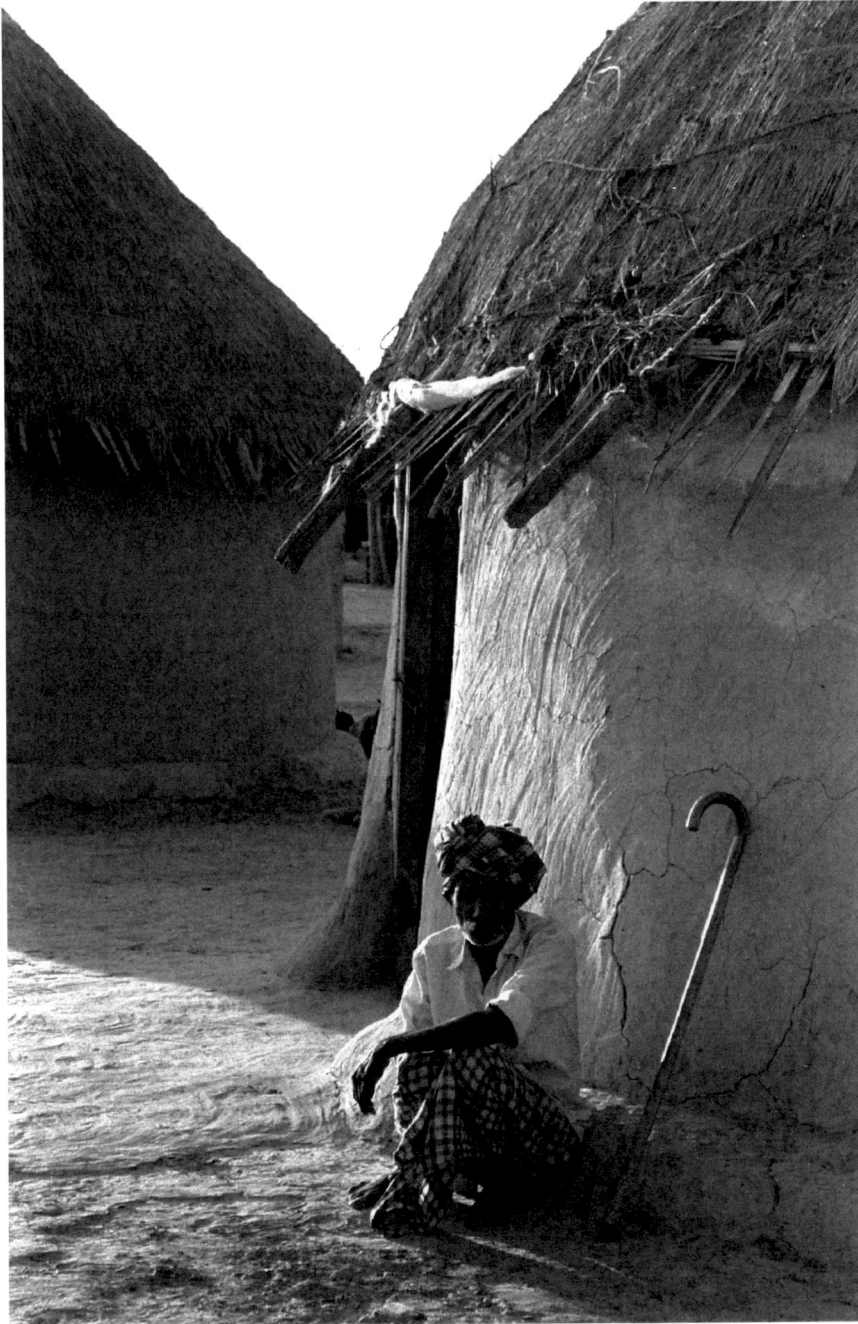

Bhirandiara near Hodka

The Ganda Bawal tree was planted in the Banni area to combat salinity but it became invasive. Local people were encouraged to make charcoal from it instead and gain an income but this idea rebounded as the trees diminished and these people continue to be very poor.

Bhuj.

Hamirsar Lake with the Prag Mahal tower in
the distance.

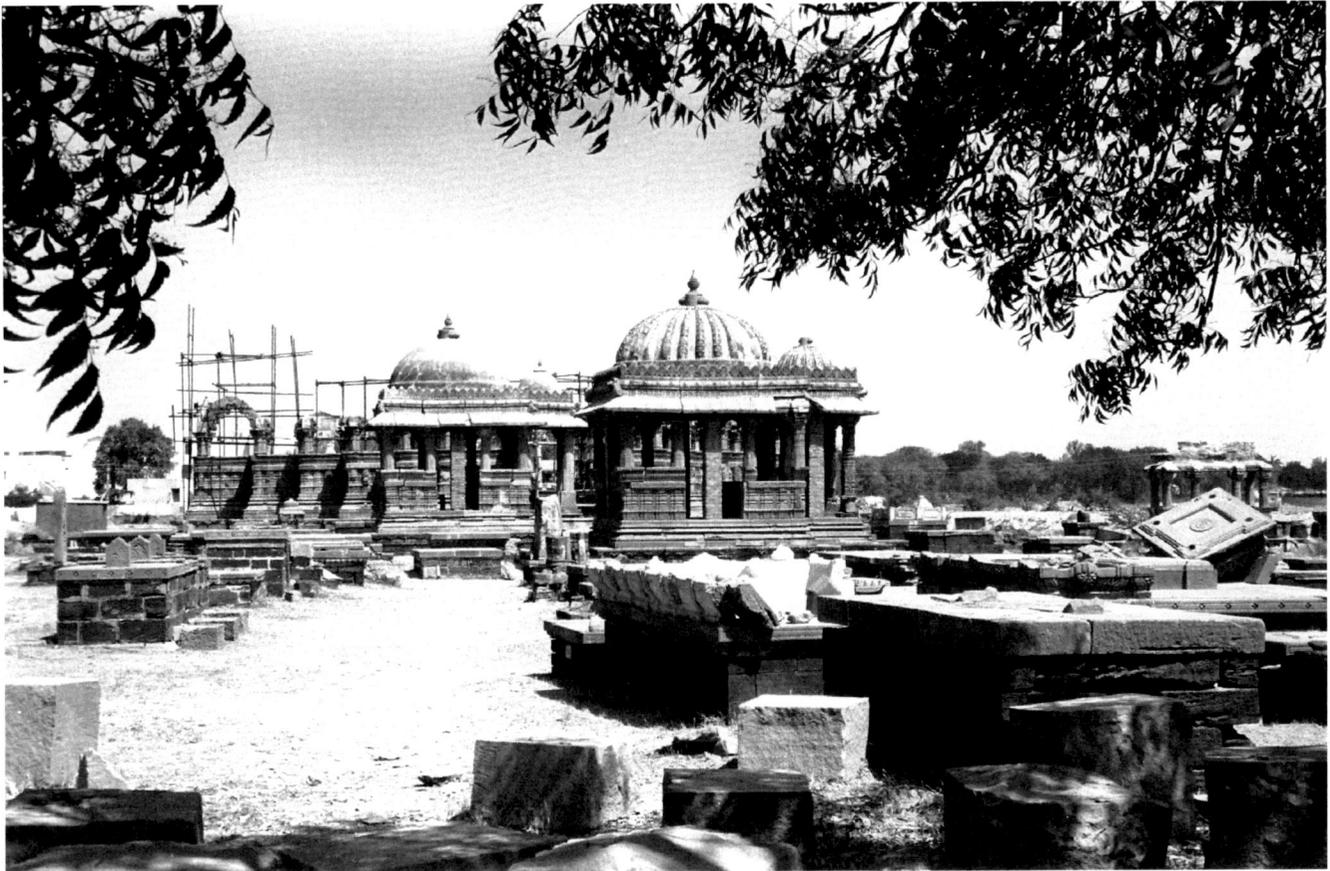

Bhuj, the Chattris of the Maharaos of Kutch.

To the west of the city and next to Hamirsar Lake lies this excellent collection of cenotaphs built in red sandstone. It was badly damaged in 2001 and restoration continues. Even now one would be hard pressed to find a finer and more varied collection of carvings that relate better the story of the Maharaos. Acknowledged to be the best is that of Rao Lakhpatji built around 1770, which has been restored superbly.

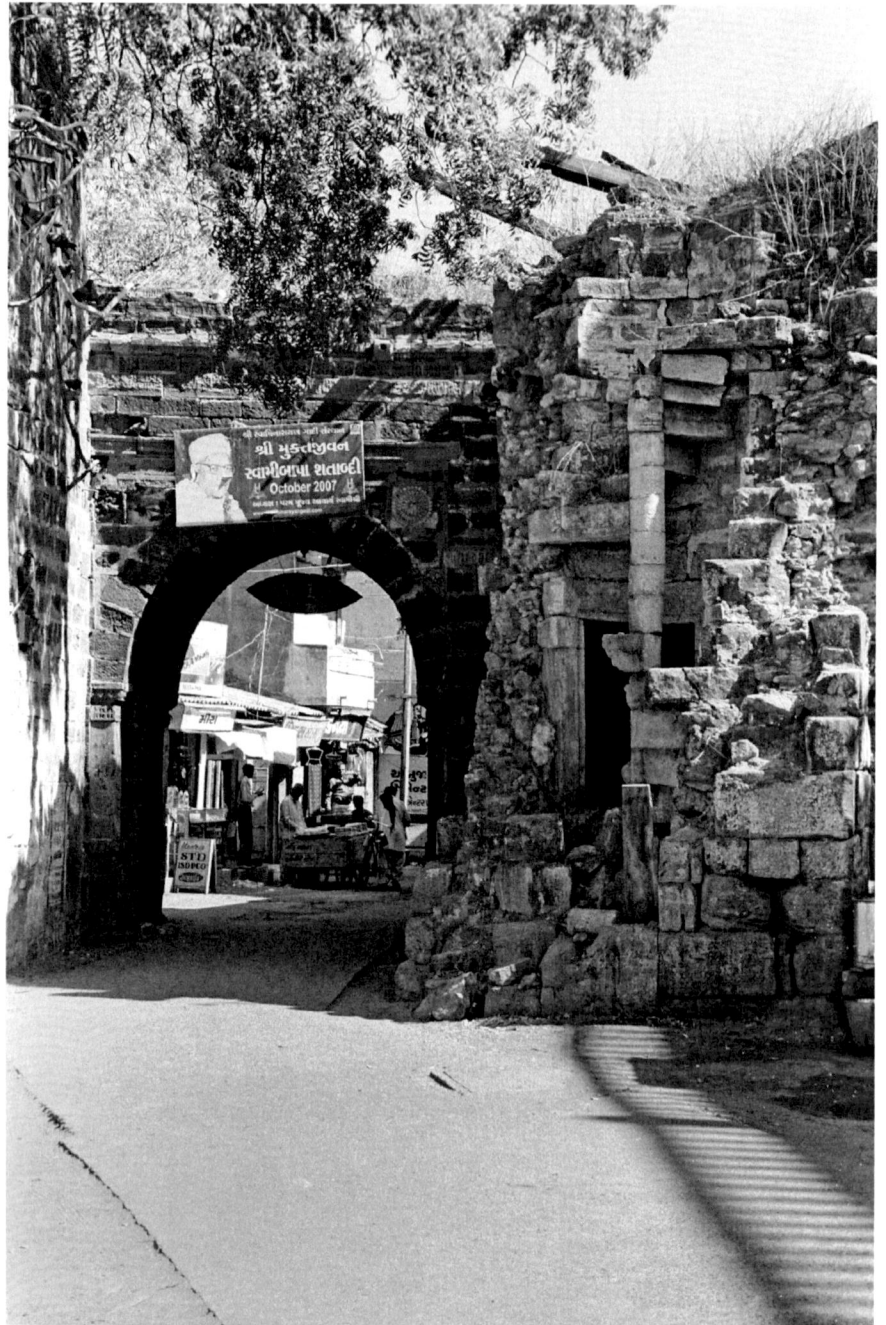

Bhuj, gateway to Saraf Bazaar.

The earthquake of 2001 peeled back layers of fortification and revealed this spiral staircase which some say used to be a secret escape from the city.

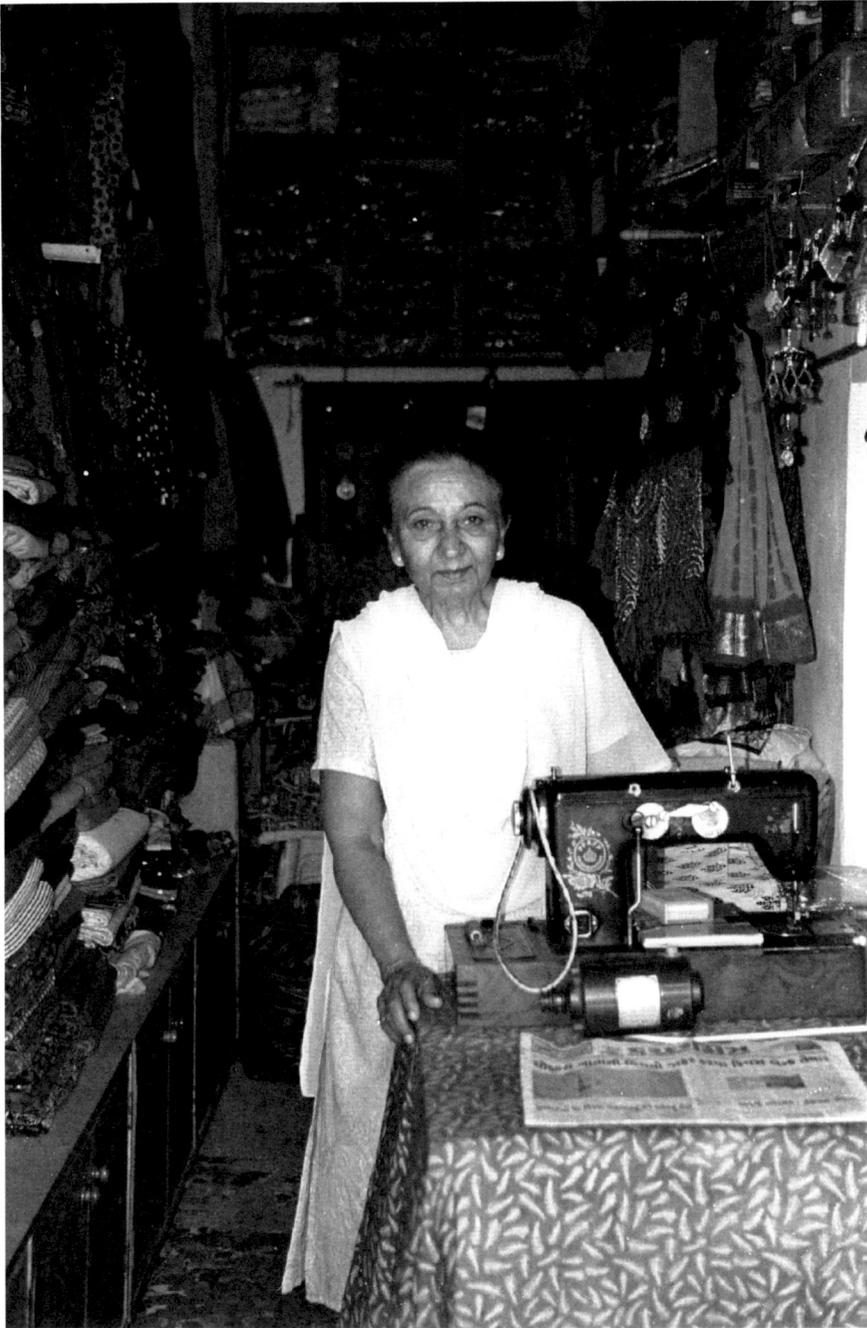

Bhuj, Senorita, a shop in Saraf Bazaar.

Much damage was done in this area but the Calcutta-born owner's shop was not hit. Her home however suffered so many frightening aftershocks that she moved away. People are much more ready to talk about the effects of 2001.

Bhuj, sugar cane juice machine in 1995.

It survived the earthquake and is now
installed outside the city gate leading to
Saraf Bazaar.

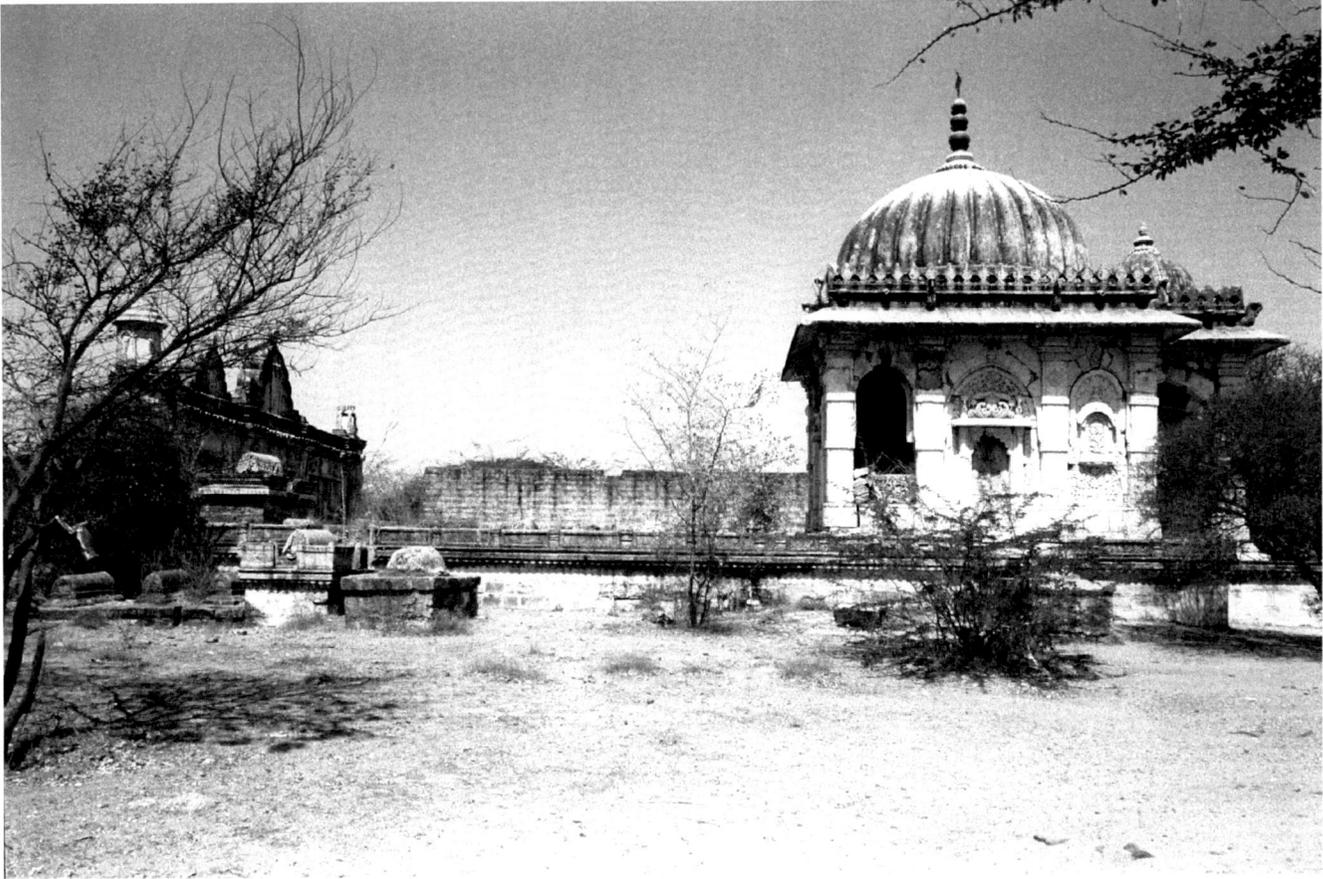

Bhuj, Fatehma Hajira.

This Dargah or shrine was built above the
tomb of Fateh Mohammed in the early 1800s
and is a heritage building. It is unlikely to
be restored, which is in line with the Kutch
attitude to conservation and heritage. Many
fine but damaged buildings are being left
to rot or demolished to make way for new
buildings.

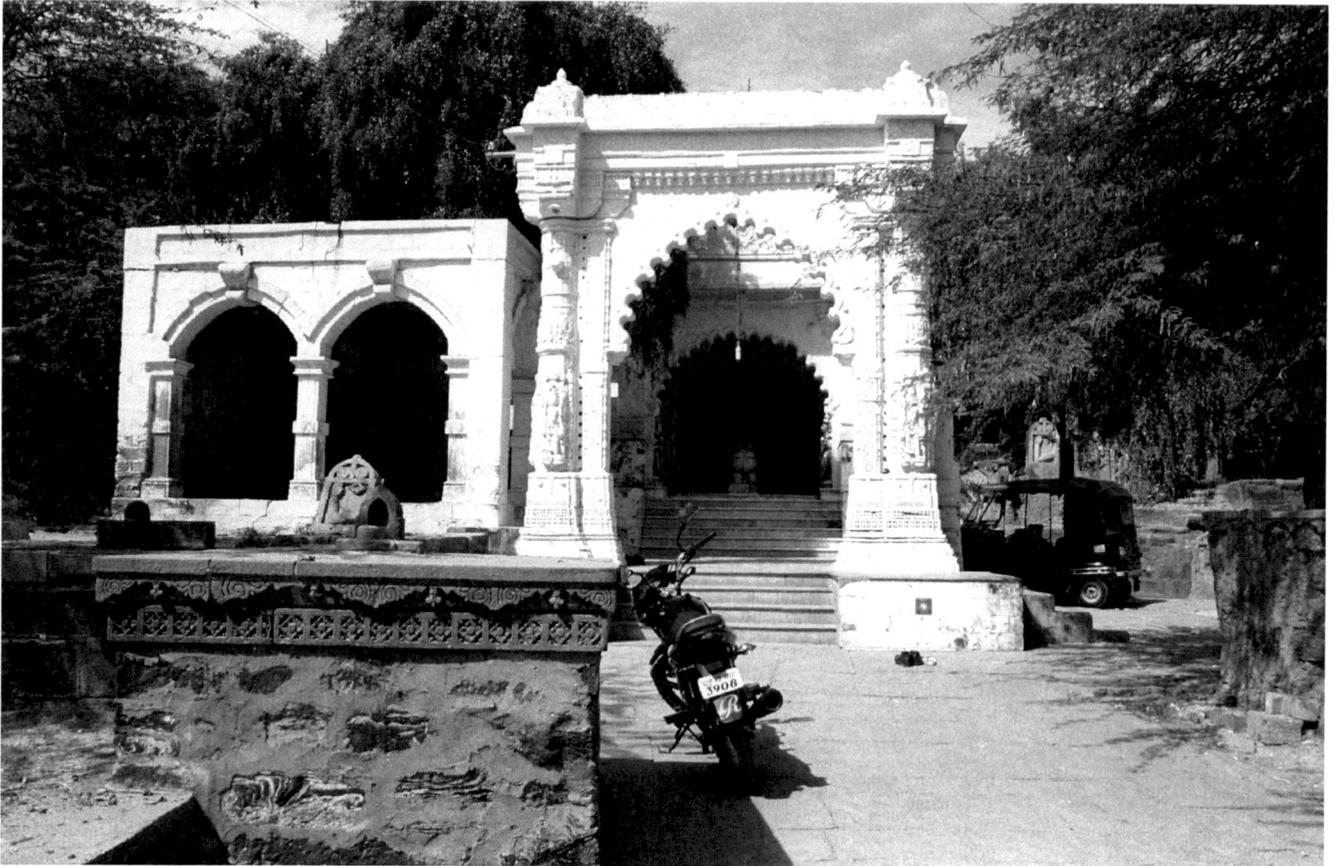

Bhuj, gate to Kalyaneshwar Mahadev Shiva
Temple. c. 1550 AD.

One of the oldest temples in Bhuj. A young
man parked his motorcycle in the centre
of the photograph and then told of his
amazement that this place should survive for
centuries whereas in 2001 he had witnessed
a long four storey block of flats and shops
opposite being 'shot down', as he put it,
rather like a cannonball going through the
middle from end to end. It is now rebuilt.

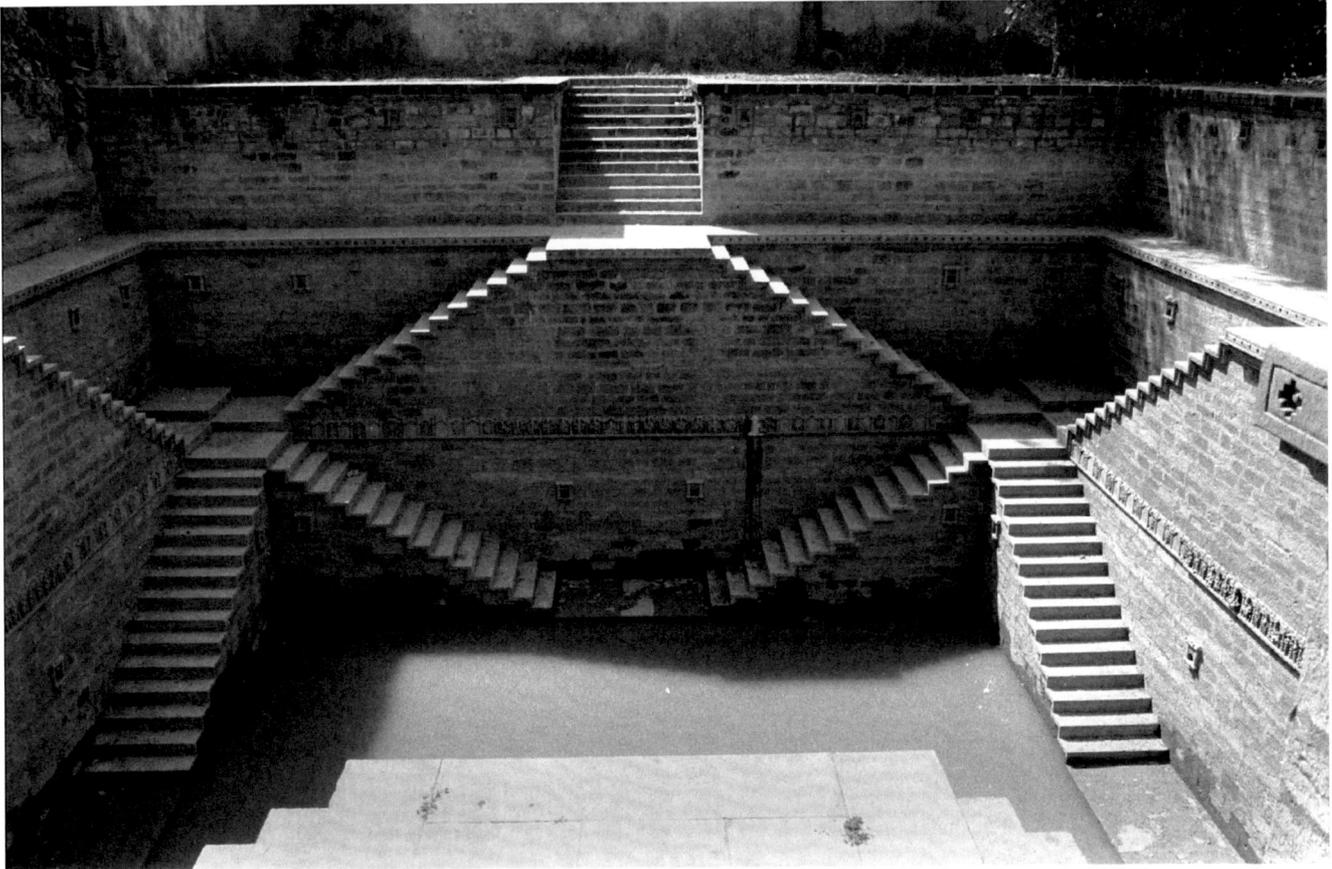

Bhuj, Ramkund.

A 700-year-old step well beautifully restored under the direction of the Archaeological Survey of India after the 2001 earthquake. It has ten incarnations of Vishnu carved in the sides.

Mandvi

Mandvi has long been the junction of the maritime spice trade route and the desert camel caravan. There is a great tradition of trading with East Africa, the Malabar Coast and the Persian Gulf.

Now, on both sides of the Rukmavati River, there is a huge amount of shipbuilding, a Muslim tradition that has continued for 400 years. Everything is done by hand except for the electric saw which cuts huge lengths of timber, and keeping to the chalk line by use of pulleys. Teak is used for the keel and lower hull; the rest is acacia. The hulls of the 1500 tonne dhows are towed across the Gulf for fitting out in Oman; merchants are now calling for larger boats of 2000 tonnes.

The 16th century town is worth a visit and parts have the feeling of Venetian balconied town houses. Just down the road is the beautiful expansive and practically deserted beach next to the unusual 1920's Vijay Vilas Palace where the current Rao lives following the shattering of his palace in Bhuj in 2001.

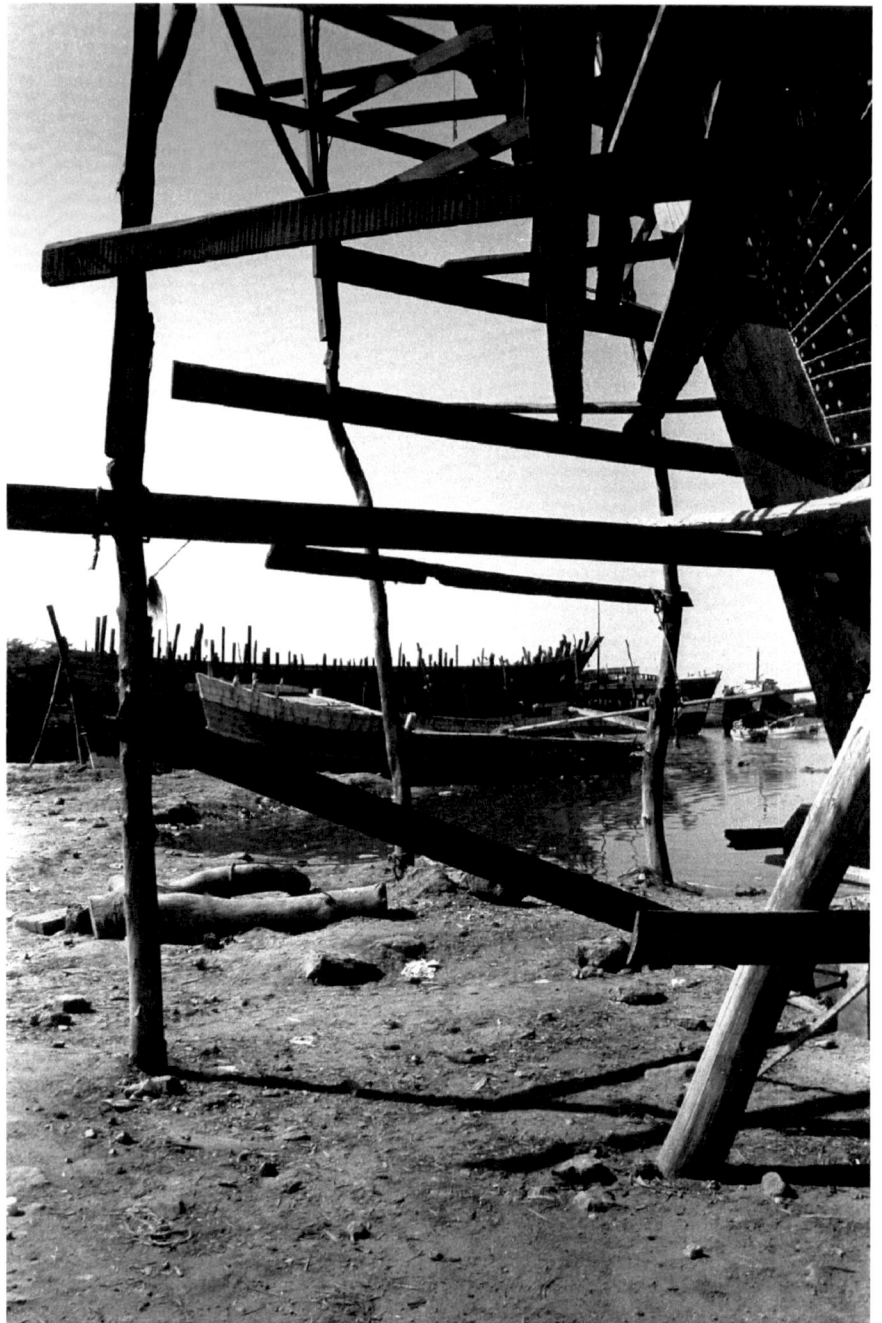

Mandvi, dhow hulls under construction on the banks of the Rukmavati River.

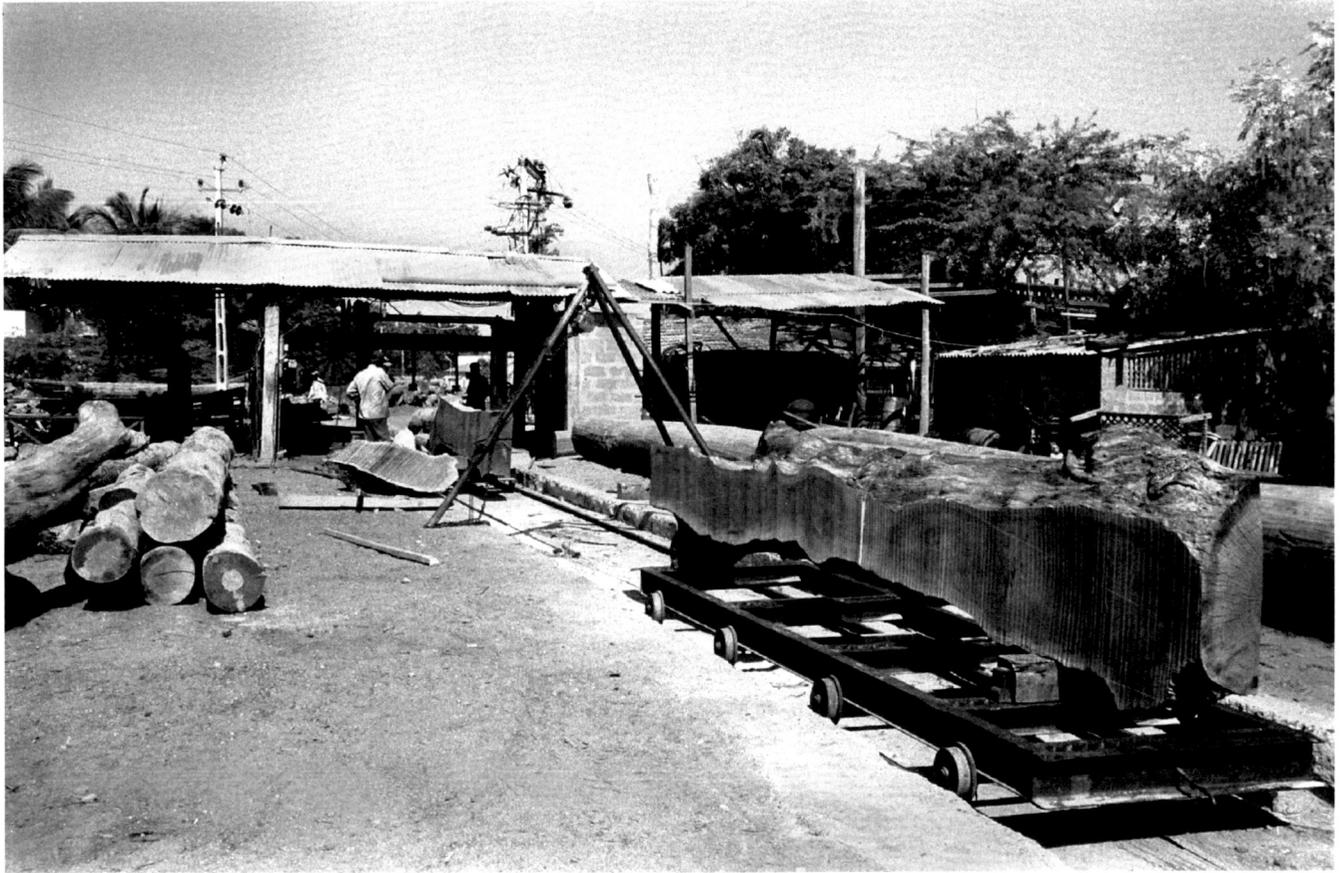

Mandvi, sawmill.

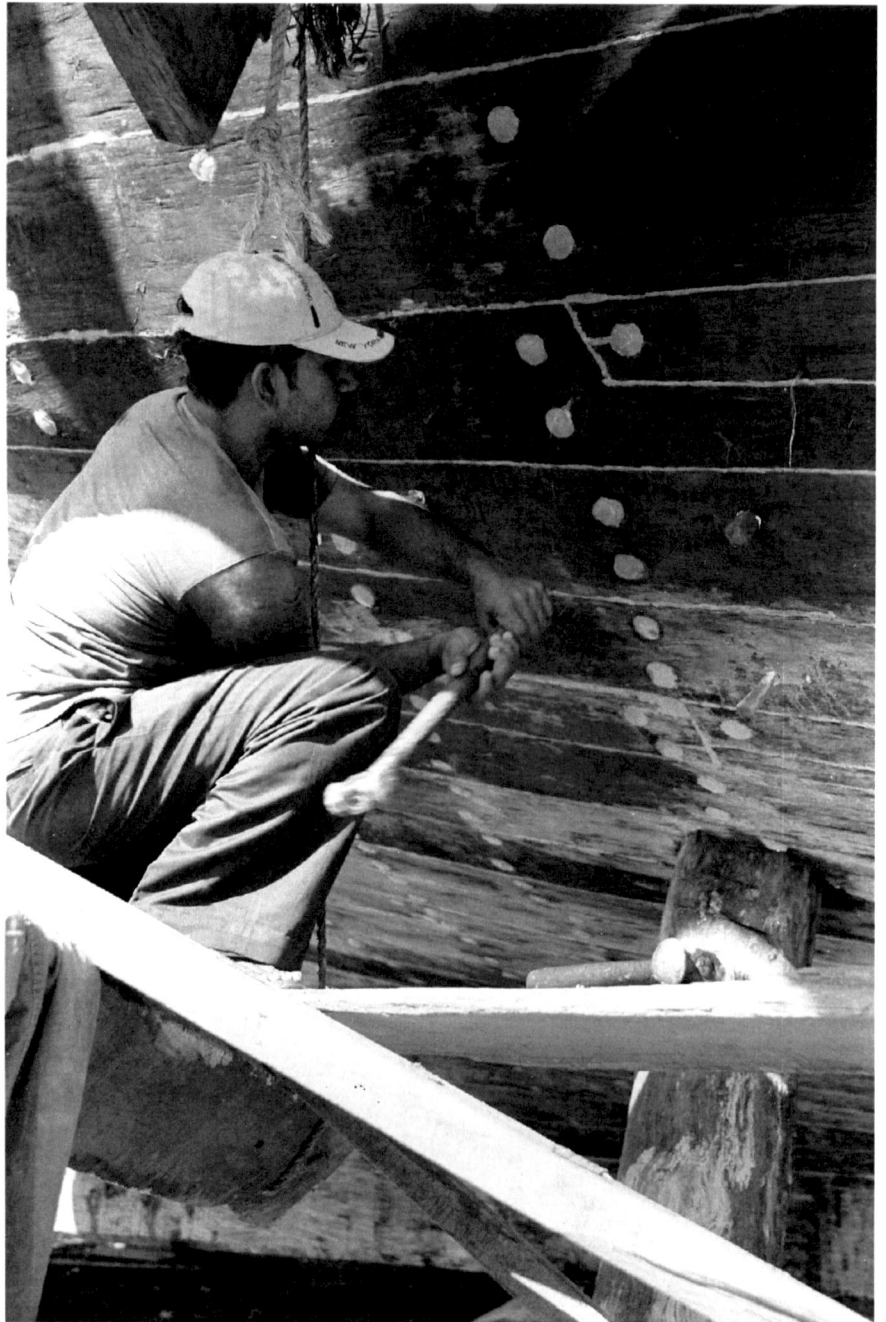

Mandvi, pelleting and caulking.

[60]

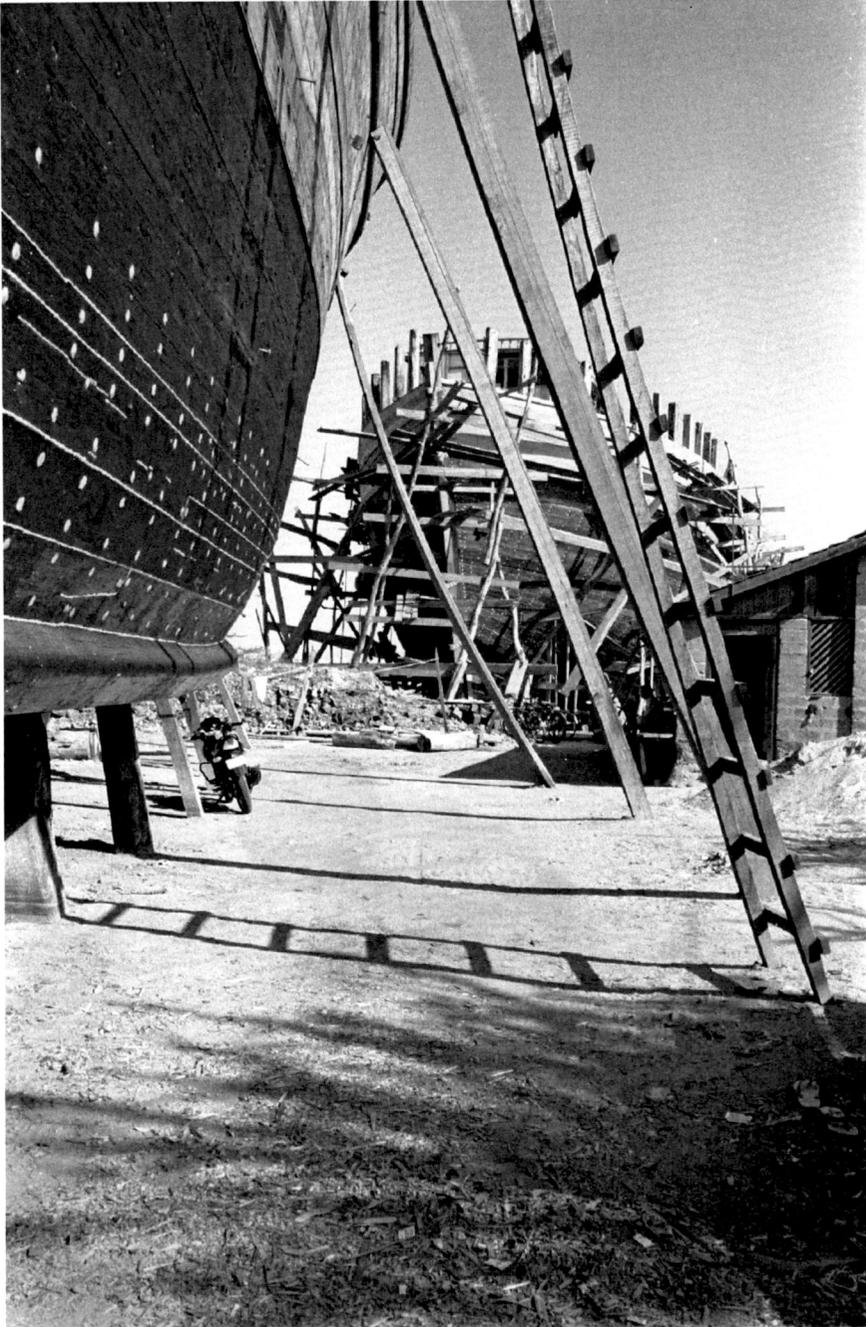

Mandvi, dhow hulls.

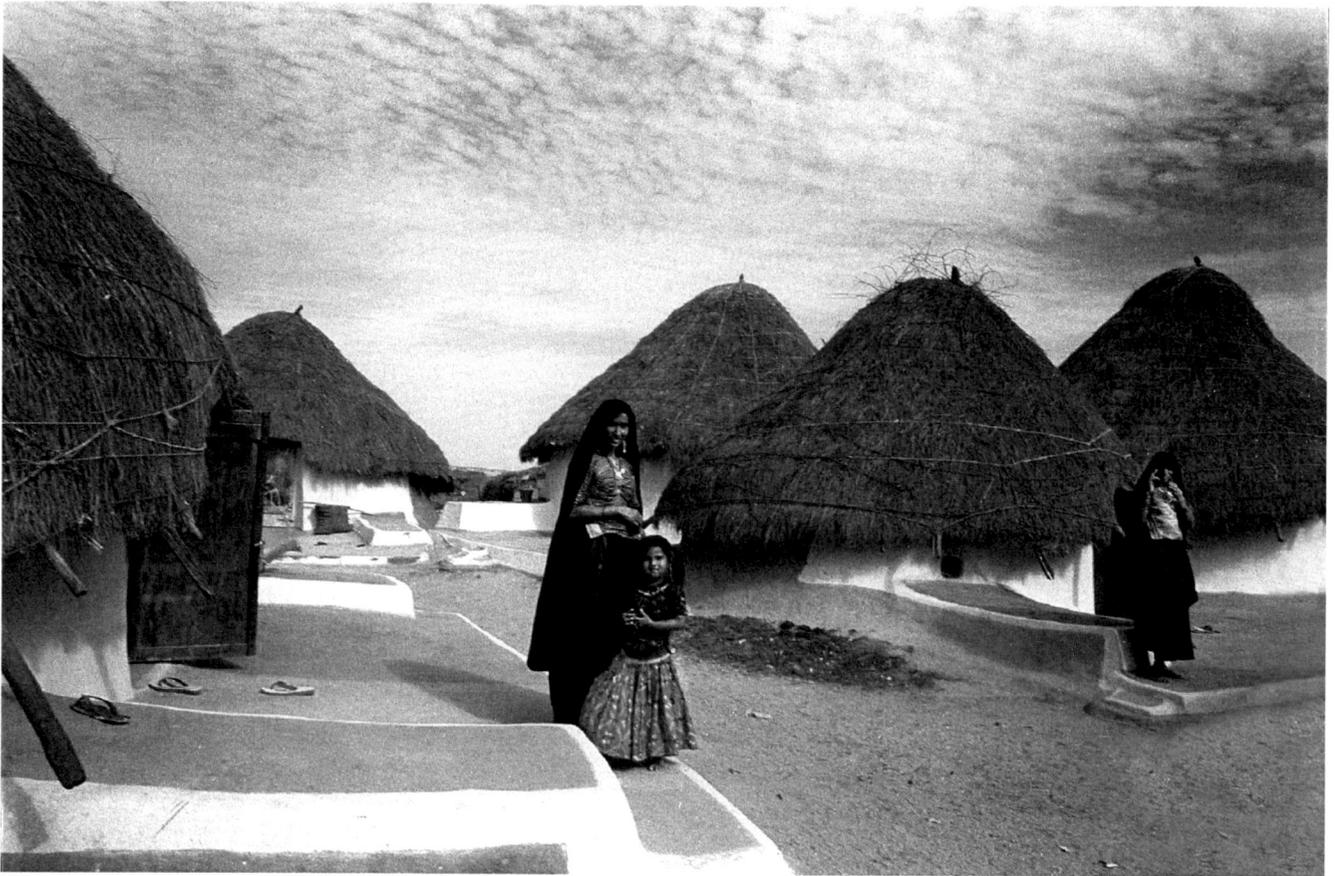

Rabari people

These are semi-nomadic people originating from western Rajasthan and the northwest who live by breeding sheep and goats for wool and milk. Traditionally they moved from one farm to another, trading dung for grazing, but now many live in bhungas in settled villages with their own Hindu temple. There are three main groups of Rabari, the Kachchhi in the west, the Dhebaria in the centre, and the Vagadia in the east. Each has at least 10 subgroups. Rabari traditionally educate their children orally but the quota system gives a percentage of school places to such minority groups. This is changing their traditional lifestyle so they can get work in towns and industry.

Much has been recorded about their remarkable textiles and jewellery. Often the artefacts tell of their traditions through symbols whilst the unique gold ornaments show status.

Now these fine pieces are diminishing. Some women still produce pieces for dowries and for selling, but the Vagadias have banned this due to the high costs.

Older women are proud of their tattoos which may display a symbol of Krishna and family names but children are resisting this tradition. Rapid expansion of industry is forcing these people to change their lifestyle and many men are now labourers, a trend that is likely to continue.

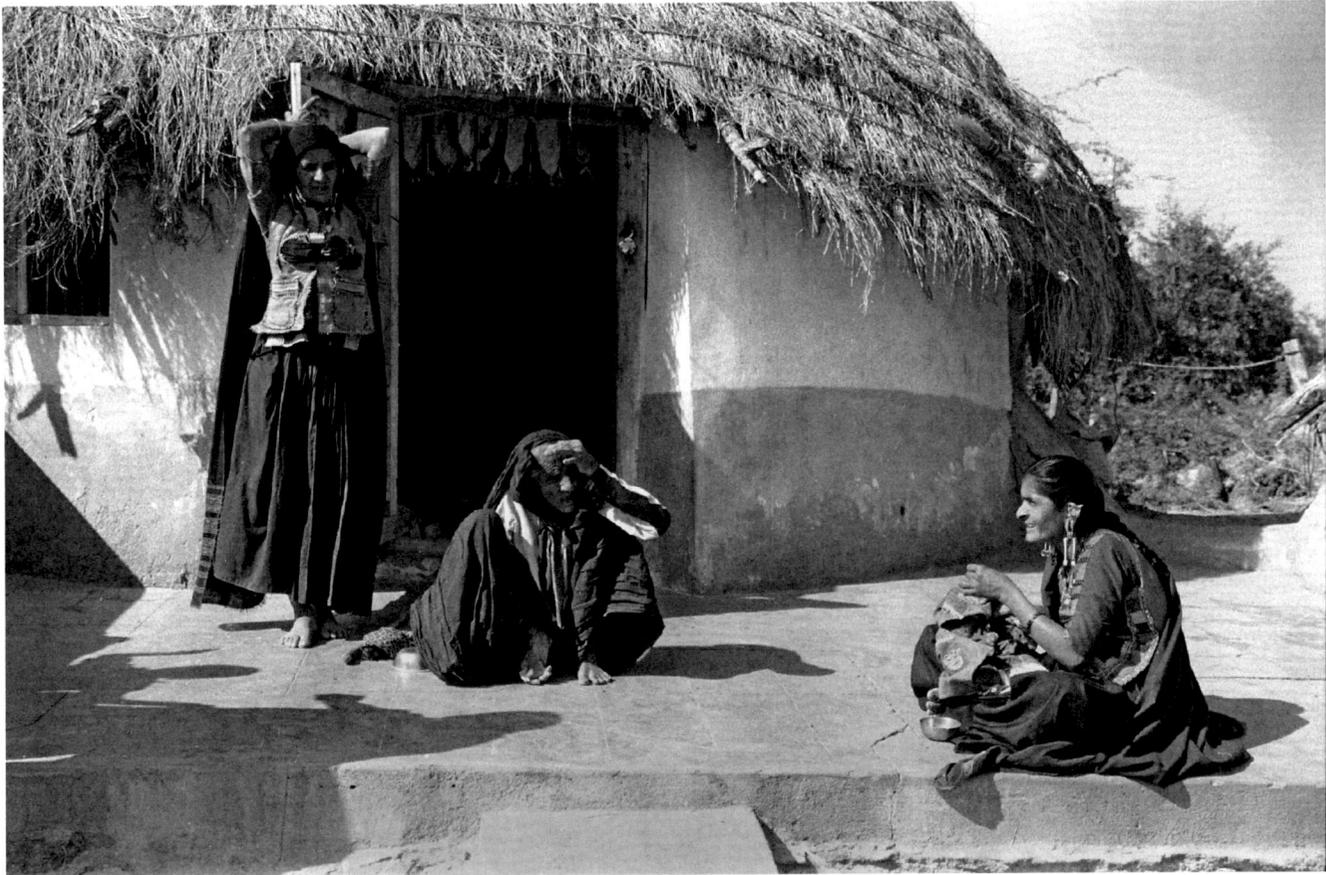

One of the few remaining habitable bhungas in the same village after the 2001 earthquake.

(Facing page) Tunda Wandh, the village in 1995.

This image shows the Rabari village before the earthquake and industrial development. At the time it was also used as an open air film set.

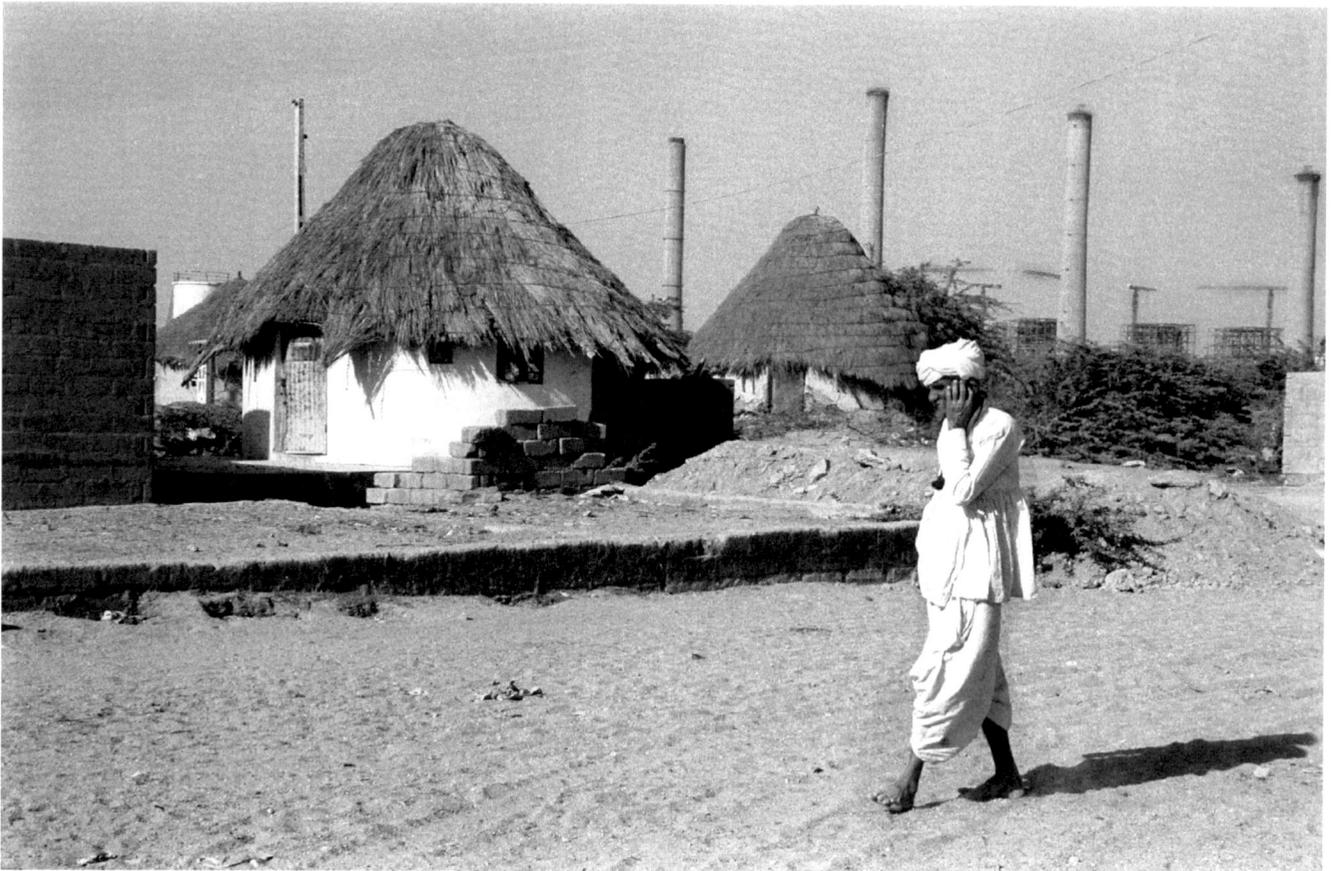

Tunda Wandh.

It is difficult to believe that this is the same village as on page 62. Most bhungas have been replaced by simple standard rendered block walls with red tiles for the roof. A bathroom block is attached so there are better amenities. The power stations under construction use Rabari labour now.

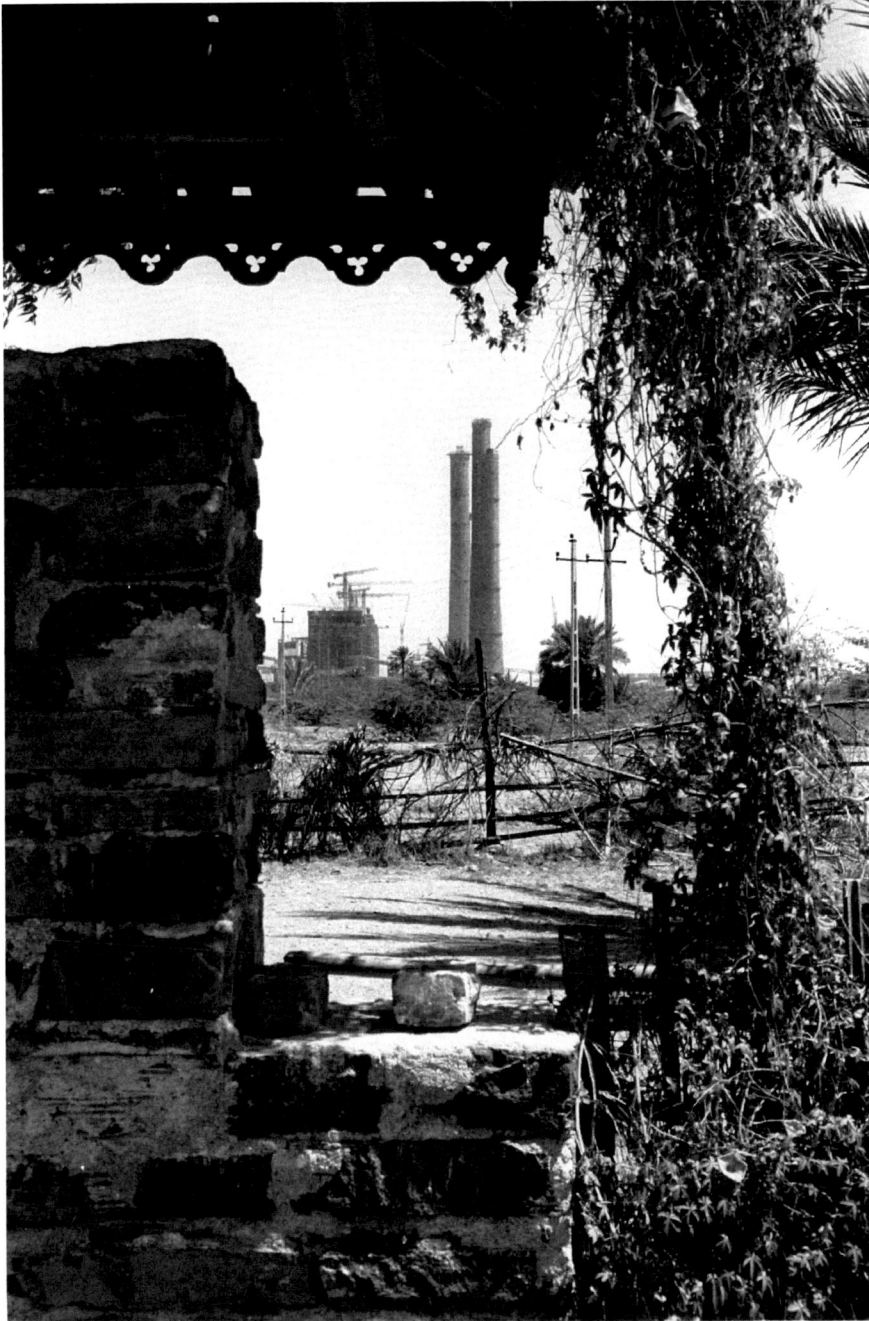

Near Mandvi, Kala Raksha Vidayala.

This is a remarkable design school where skilled Kutchi artisans take a year's course in design and marketing. The three chimneys only hint at the two massive 500 megawatt power stations being built and the foundations laid for huge factories. The school was made using recycled materials in open country but the emerging pollution and intrusion mean that it will have to move.

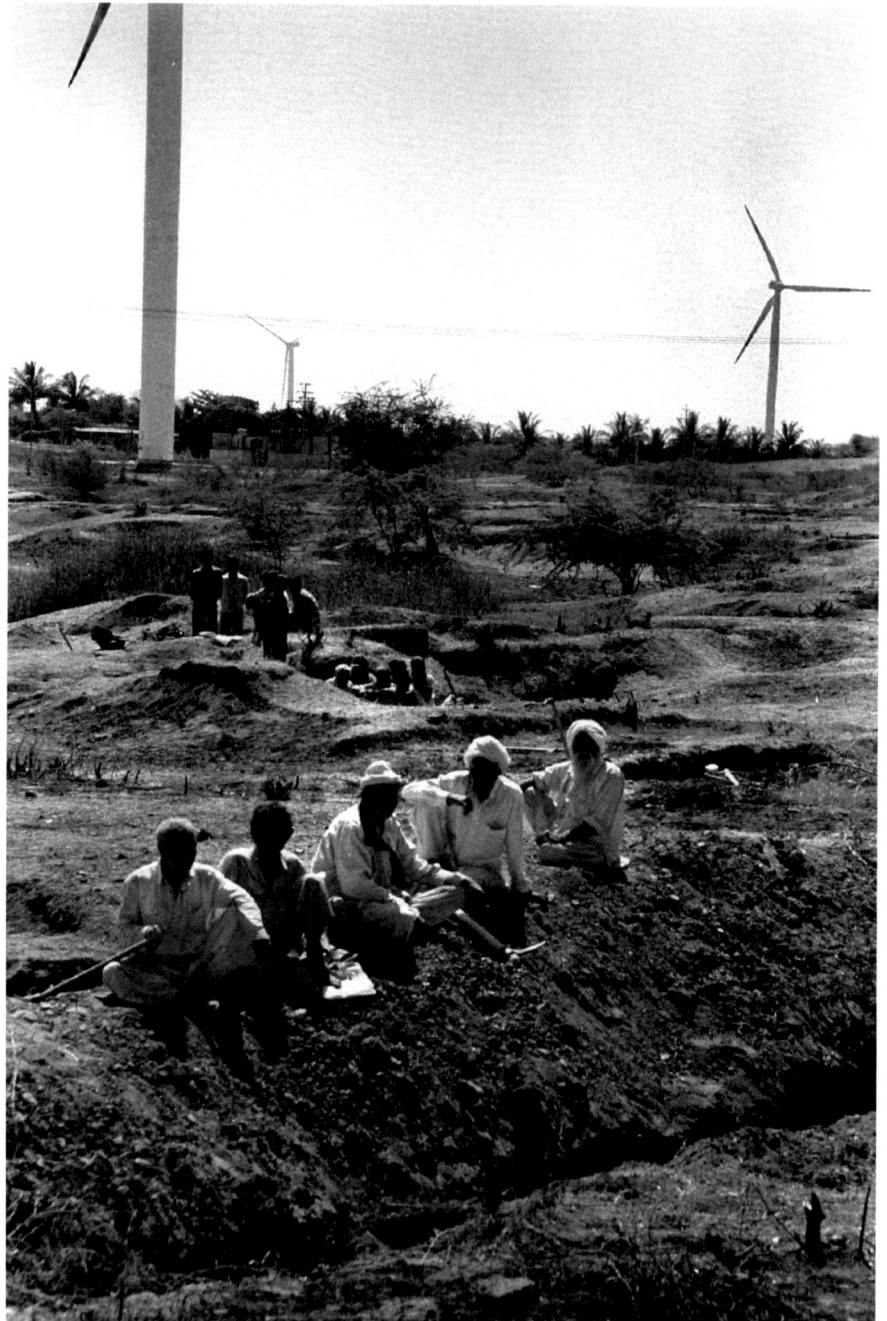

Between Bhuj and Midialo, wind farm under construction.

This looks innocent enough but it is worth noting that each turbine needs 2.5 acres to operate and large tracts of unspoilt land-scape are changing. Farmers are keen to grant leases for such land for a good return. Who can blame them.

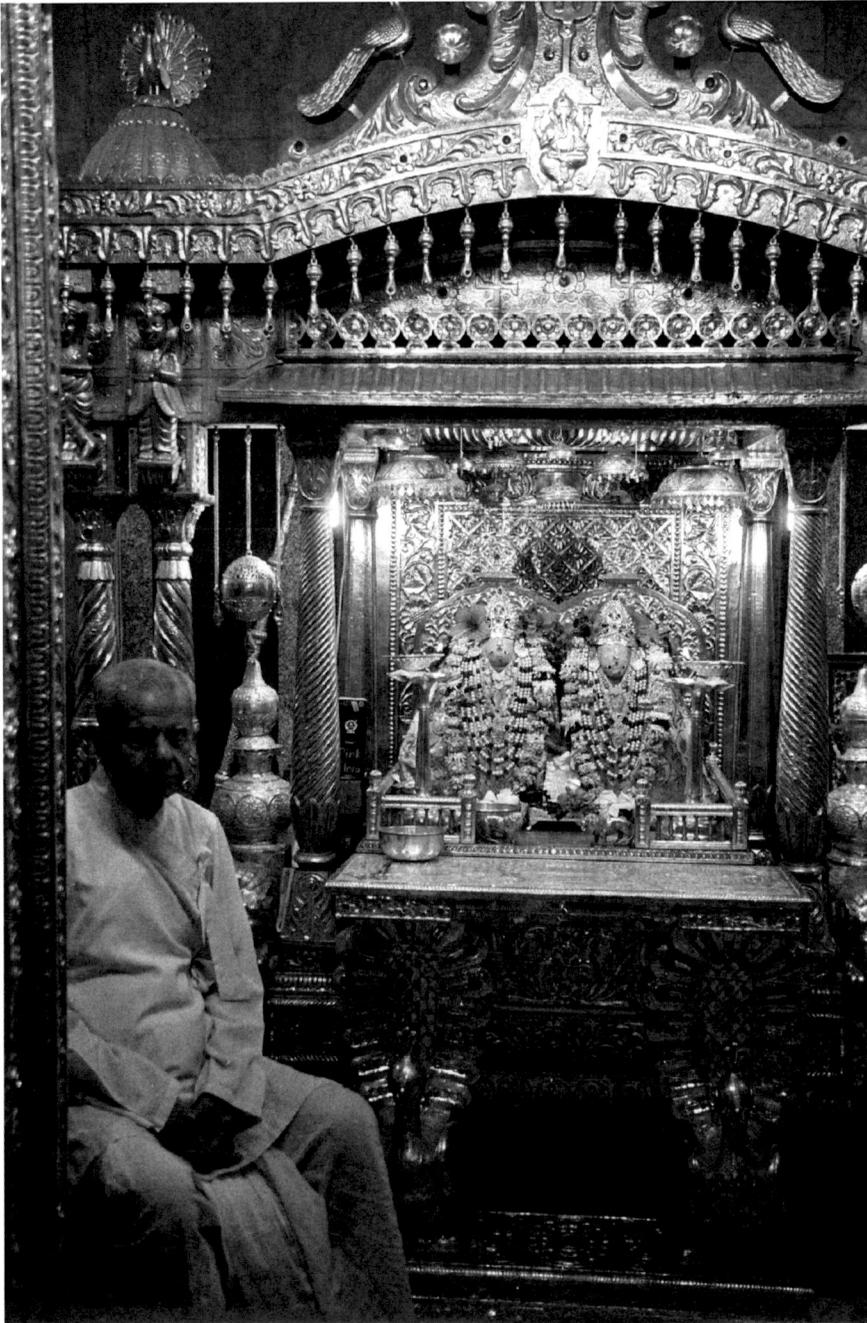

Bhuj, Ashapura temple.

The Royal Temple is in a beautiful peaceful area. The two deities come from the fact that one went missing for many years, a copy was made, and suddenly the first reappeared.

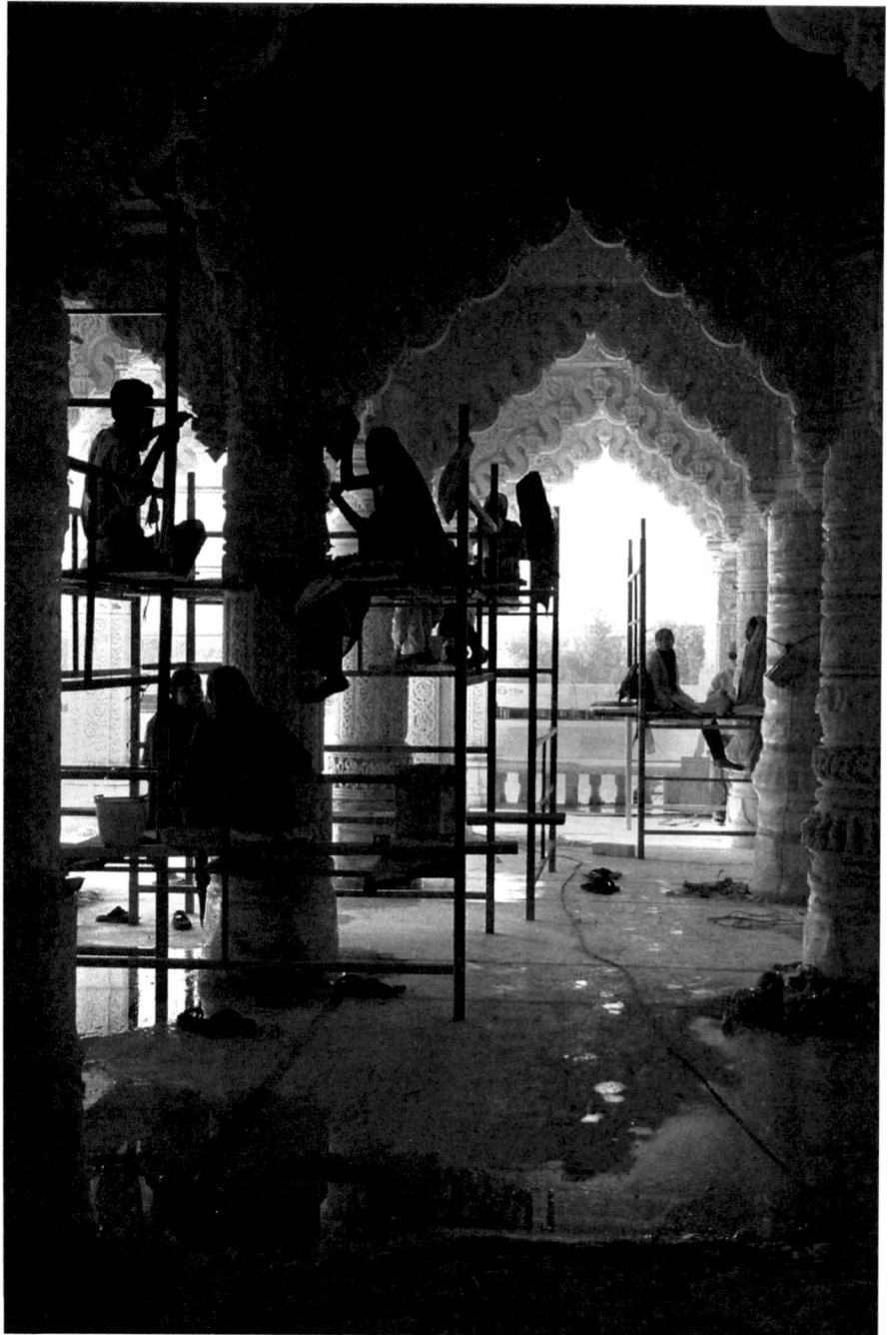

Bhuj, Swaminarayan temple.

This is an extraordinary temple built with great skill and at vast expense. It is surprising that the carvers and finishers come from Rajasthan and many are women.

The emerging future

Kutch has significant disadvantages. The most obvious are that it is a remote island with exceptional geological faults, and that it has an unreliable climate, limited natural resources and insufficient fertile land for growing crops. But it has a low population per square kilometre. Migrants even as far back as 5000 years ago were generally pastoral or cattle breeders from the north attracted by the suitable grazing land. Now, much of the land suffers from increasing salinity in spite of various projects to arrest this trend. Kutch is in the so-called 'famine belt' and is greatly dependant on variable monsoons. There is a general shortage of water worsened by an increasing population and the demands of industry.

From the 1500s the rulers had to run the state without being able to raise funds from half the land. Further, their own relatives, the *bhayyad* chieftains, were content to run their fiefdoms in near isolation. The British refused to allow the state to use its accidental vast salt deposit for its own profit. It is surprising therefore that the Maharaos, with such limitations, commanded such respect within the British Empire.

So what are the assets now? For centuries Kutch has enjoyed an extensive coastline suitable for fishing and leisure. Likewise there are several ports that trade with parts of India, Africa and the Middle East and more recently there are two major deep-water ports, one at Kandla, the second largest in India, and the other which is the largest Indian private port of Mundra owned by Adani. The latter is the shortest land route from the vast area in western and northern India. These are not illustrated but just imagine Mundra Port with state of the art facilities, 25 berths, oil tankers, chemical storage and some of the largest container ships on the planet.

The salt pans are still there, in private ownership, producing great wealth except for the 60,000 Koli workers and the salt is exported as far away as Taiwan and Korea. Parts of Kutch have extensive minerals such as gypsum, lignite, limestone, bauxite and coal, which are being progressively extracted. These processes all require energy and there has been a great increase in coal-fired power stations and in turn manufacturing development.

Kutch has a reputation for interesting unique craftwork and textiles. These were born out of everyday needs and customs mainly in ethnic communities but traditions are changing and if they are to survive the objectives may have to change too.

In the Great and Little Ranns there are marshy areas and shallow lakes which provide for abundant birdlife including Flamingo City, one of the few major breeding areas in the world and of course the Indian wild asses.

The countryside is largely unspoilt and has a peaceful atmosphere that is rare. In the towns and cities there is much for the visitor to see and enjoy without hordes of other tourists. On the downside the infrastructure remains poor and from the tourists point of view there are few quality hotels and some may be put off by the vegetarian diet or the lack of alcohol which requires a permit. At the moment it offers weak competition with neighbouring Rajasthan.

The Gujarat government, however, offers major investment incentives and tax concessions intended to expand the state's wealth. Kutch is a main target; this presents promising opportunities for these resilient people.

Since the 2001 earthquake many buildings have been restored, the population has increased and the infrastructure is improving; this work continues and inevitably throws up conflicts. It is beyond the scope of this book to discuss the future in depth so these are personal observations aimed at giving an overview of imminent changes.

Kutch is next to Pakistan and there is evident tension due to illegal trafficking. Currently 118 km of fencing remains incomplete. An elevated road is proposed to give better access to Border Security Force outposts in the Great Rann. This would pass through the Wildlife Sanctu-

ary where flamingos breed and close to Dholavira. Environmentalists are objecting.

Industrial development is moving fast. The Gujarat Mineral Development Corporation plans a one million tonne aluminium refinery and a 500,000 tonne smelter. Tata Power is another big player in industry throughout India even though 60 per cent of its business is done overseas. It often has great difficulty acquiring land due to conflicts between development and the environment. However with Government incentives it is commissioning an 800 MW power unit as the first of five in its 4000 MW Ultra Mega Power Project at Mundra. Adani and Tata have each built a 500 MW power station near Mandvi to supply a belt of new factories near the coast. There are others such as Sanghi Ltd. for cement and Welspun Power and Steel. These account for 39 per cent of Gujarat's industrial projects.

As elsewhere in India useful natural resources are found in areas of fine landscape. Inland from the northwest coast Panandhro Mining Company is carving hills to mine lignite and the land reformed afterwards to simulate hills and lakes. This is on a big scale (59m tonnes) and parks for 1000 lorries are not uncommon.

Conflicts are inevitable. Recently 10,000 fisherman, farmers and salt pan workers held a protest march. The fishermen say that port expansion and shipping is destroying their traditional fishing grounds. The High Court has stopped Adani from developing near the coast in a Special Economic Zone due to destruction of mangrove forests, which are vital for coastal soil conservation.

It is state policy to harness wind power and Gujarat currently produces 15 per cent of India's total wind power. Near Mandvi the skyline is full of turbines and likewise on the attractive west coast. Environmentalists say that the rare great Indian bustard is now a threatened species.

The state government has been accused of dubious land acquisitions, selling cheaply, and misuse of post-earthquake land allocations. Corruption is common and major companies are held back by bureaucracy and the Licence-Permit Raj. The activist Anna Hazare is the non-violent leader of the 2011 anti-corruption movement and is now being noticed. The big firms like Tata are also taking a firm stand against corruption.

Recently there has been great success in horticulture which has increased by 30 to 40 per cent in five years mainly in the production of fruit such as mangoes, bananas, papayas and amla. Firms like Agrocel have mobilised farmers to produce different types of Fairtrade cotton whilst Excel Crop Care enhance food production.

Several companies operate a variety of community development projects such as income generation, social infrastructure, health, polio immunisation, hygiene, sanitation, veterinary training around their operation areas. These mainly benefit their own employees but have a wider significance.

Gujarat tourism is promoting with limited success festivals such as Rann Utsav, the Kite Festival and the Kutch Festival. There is scope for those interested in wildlife and beach tourism. Amitabh Bachchan, the Bollywood megastar Big B, has been taken on as ambassador for Kutch and has made a few promotional videos. There is already a small-scale trail to learn about textiles and local crafts. The traditional heritage is vanishing fast so this needs care if the local artisans are not to be exploited through crude sales cooperatives. And some crafts are likely to die or become folksy.

The population and wealth is growing quickly but Kutch needs more proper schools, welfare, and housing. There are many poor people but in spite of the law funds are siphoned off. Ethnic groups like the Jats, Ahirs, and Rabari should manage to retain their pastoral ways except for those squeezed by new industries. In his book *India: the road ahead* Mark Tully refers to traditional *jugaar* or 'muddling through' and concludes that a new ethos is needed whereby policies are followed and rules obeyed. He is optimistic. For India, and even more so for Kutch, this is the time for good governance and careful change.

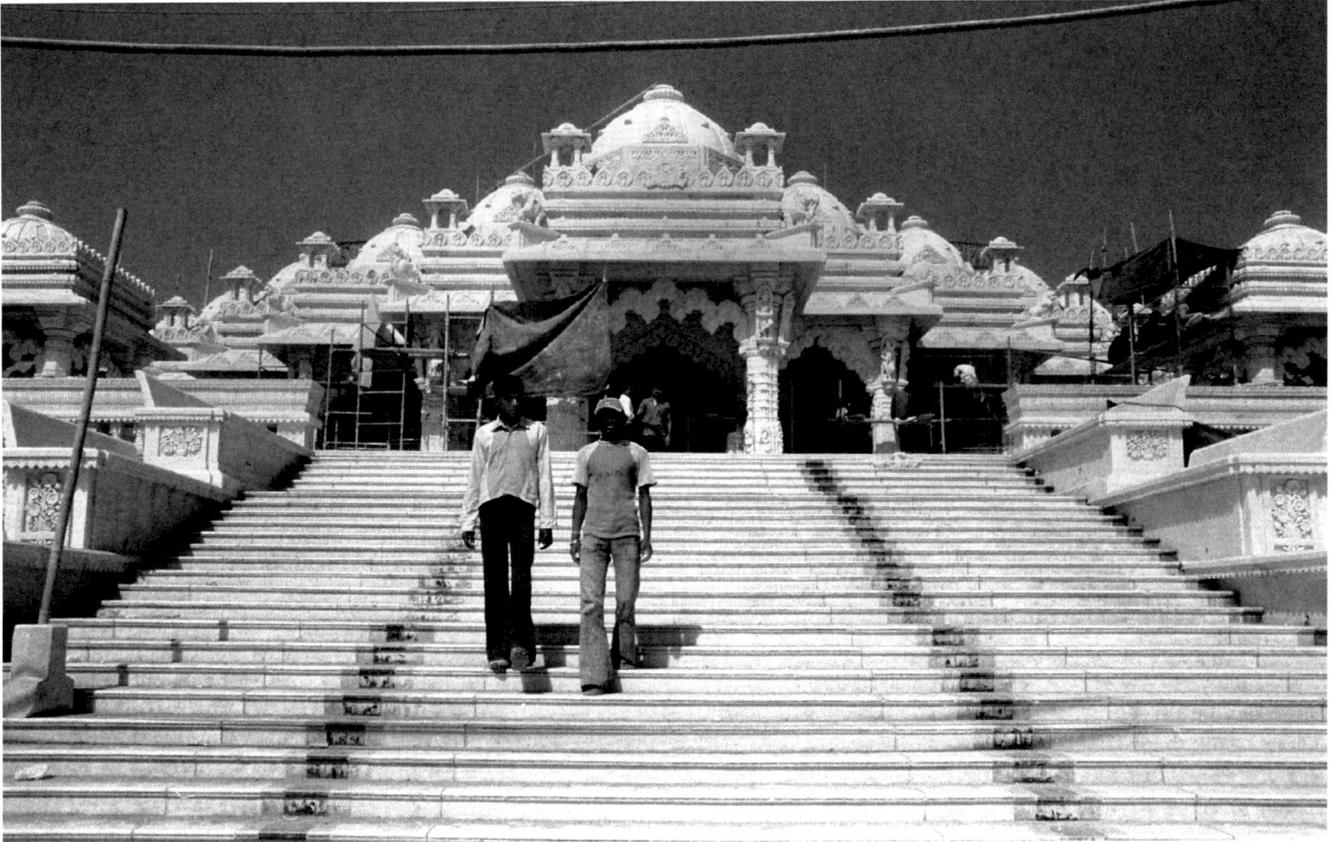

Bhuj. Swaminarayan temple entrance.

Epilogue

It is plain that the state of Gujarat intends to continue to expand industry, power, mining and tourism in Kutch and quickly. The pressure on small communities particularly in the southeast near the two main ports is evident. In a way, Kutch has been left behind so change is inevitable and needed. How this is done matters greatly. Much of the attraction of Kutch has to do with its people, the gentle variety of landscape, its birdlife, flora and fauna. Kutch is not 'spectacular'; it is more subtle than that so it would be tragic if these characteristics were lost.

I have shown the Swaminarayan temple last. This Hindu sect is about 200 years old and growing fast. The old temple complex is restored and the new one opened in May 2010. It is colossal, beautifully made, and has a monastery for 200 monks. It cost a billion rupees to build.

The contrasts of India's massive growth rate, increasing wealth, mining the countryside, the display of opulence in such temple building, against the erosion of old cultures, heritage buildings and landscape, and the continuing struggle for life amongst the poorest people is hard to comprehend. As ever India makes one think.

Suggested reading

Williams, L. F. Rushbrook, *The Black Hills*, London: Weidenfeld and Nicholson, 1958
Probably the most comprehensive history of Kutch. Rather dry.

Fisher, Nora, (ed) *Mud, mirror and thread: folk traditions of rural India*. Ahmedabad: Mapin Publishing Pvt. Ltd, 1994
Excellent for those looking to understand the meaning of embroidery in ethnic communities. Well illustrated.

Frater, Judy, *Threads of identity: embroidery and adornment of the nomadic Rabaris*. Ahmedabad: Mapin Publishing Pvt. Ltd, 1995
An essential book for those interested in these amazing people, their history and culture. Packed with knowledge.

London, Christopher W., (ed), *The Arts of Kutch*, Marg Publications, 2000.
A personal favourite. Wide-ranging with everything from architecture through crafts and textiles to an excellent chapter about silver.

Jadia, Umesh, *KACHCHH*, Bhuj: Radhey Screen Printing, August 1999
Despite an unprepossessing cover and lack of illustrations there is a wealth of useful information here; I wish I had found it sooner. Nearly half the book is about the expressive Kachchhi folk music and instruments.

Postans, Mrs, *CUTCH or random sketches*, London: Smith, Elder and Co, 1839. Available as a reprint.
Mrs Postans lived in Kutch for several years. Her book gives a lively account of her observations at that time.

Jethi, Pramod. J., *KUTCH People and their handicrafts*, Bhuj: Nayana P. Jethi, 2008
The author is the enthusiastic and helpful curator of the Aina Mahal Museum. No tourist would be properly equipped without this entertaining small volume.

Rathod, Ramsinhji J., *Kutch and Ramarandh*, Bombay: Bharatiya Sanskriti Foundation Bhuj, 1992
In spite of its odd layout this book is notable. It illustrates the remarkable frescoes of the Ramayana in Tera Fort which are in need of restoration. The rest is full of random but informed extracts about Kutch and its culture.

Tyabji, Azhar. *BHUJ*, Ahmedabad: Mapin Publishing Pvt Ltd, 2006
Started shortly after the 2001 earthquake the aim was to map the damage to historic sites. The book has a fascinating kaleidoscopic quality with personal recollections, possible future plans, historic and current images, and is very well presented.

Tully, Mark, *India– the road ahead*, Chatham, UK: Ebury Publishing, 2011
A clear analysis and discussion about India's future.

Museums to visit

Here are just two places in Bhuj that are well worth visiting for those wishing to see fine Kutchi artefacts.

Kutch Museum
There is much about folk arts and crafts, some of very high quality. There is a comprehensive display of the geological developments and a useful overview of the Indus Valley Civilisation.

Aina Mahal Museum
This is essential viewing. It shows the heritage and culture of Kutchi fine art started by Ram Singh Malam in the middle of the 18th century under the patronage of Maharao Lakho. It is full of surprises and worth several visits.